Pastels

Painting Class

BARRON'S

Original title of Spanish book: *Pintura al Pastel*

© Copyright Parramón Ediciones, S.A., 2008 World Rights
Published by Parramón Ediciones, S.A., Barcelona, Spain
Project and Publication by Parramon Ediciones, S.A.
Managing Editor: María Fernanda Canal
Editor: Tomás Ubach
Editorial Assistant and Image Achive: Ma Carmen Ramos
and Núria Barba
Text: David Sanmiguel
Drawings and Exercises: David Sanmiguel, Óscar Sanchís,
and Mercedes Gaspar
Photography: Nos & Soto
Series Design: Josep Guasch
Makeup and Composition: Estudi Guasch, S.L.
Production Director: Rafael Marfil
Production: Manel Sánchez
Prepress: Pacmer, S.A.

Translated by Michael Brunelle and Beatriz Cortabarria

English language edition for the United States, its territories
and dependencies, and Canada published in 2011 by
Barron's Educational Series, Inc.
English edition © copyright 2011 by
Barron's Educational Series, Inc.

All inquiries should be addressed to:
Barron's Educational Series, Inc.
250 Wireless Boulevard
Hauppauge, New York 11788
www.barronseduc.com

ISBN: 978-0-7641-6389-0

Library of Congress Control Number: 2010042924

Library of Congress Cataloging-in-Publication Data

Pintura al Pastel. English.
 Pastels / [translated by Michael Brunelle and Beatriz Cortabarria].
 p. cm. — (Painting class)
 Includes bibliographical references.
 ISBN-13: 978-0-7641-6389-0
 ISBN-10: 0-7641-6389-2
 1. Pastel drawing. I. Title.
 NC880.P5613 2011
 741.2'35—dc22 2010042924

Printed in Spain
9 8 7 6 5 4 3 2 1

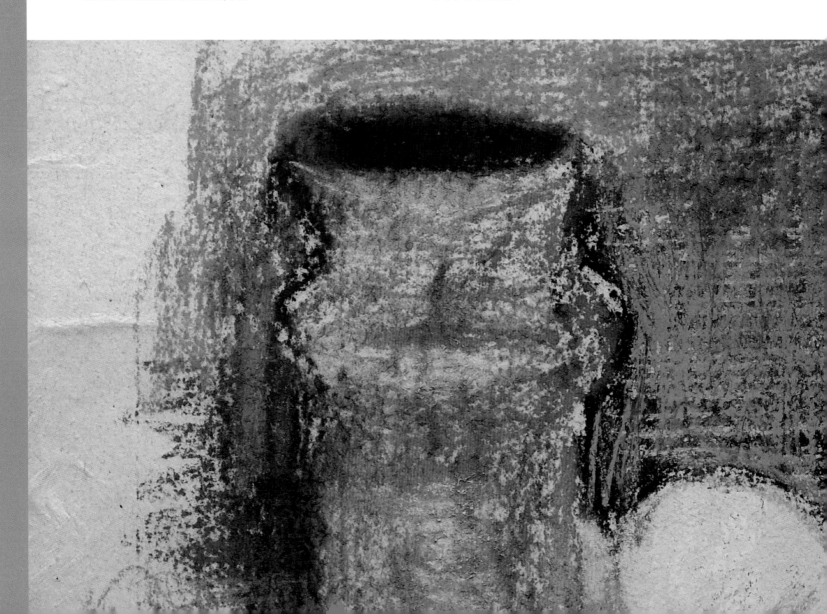

Pastels

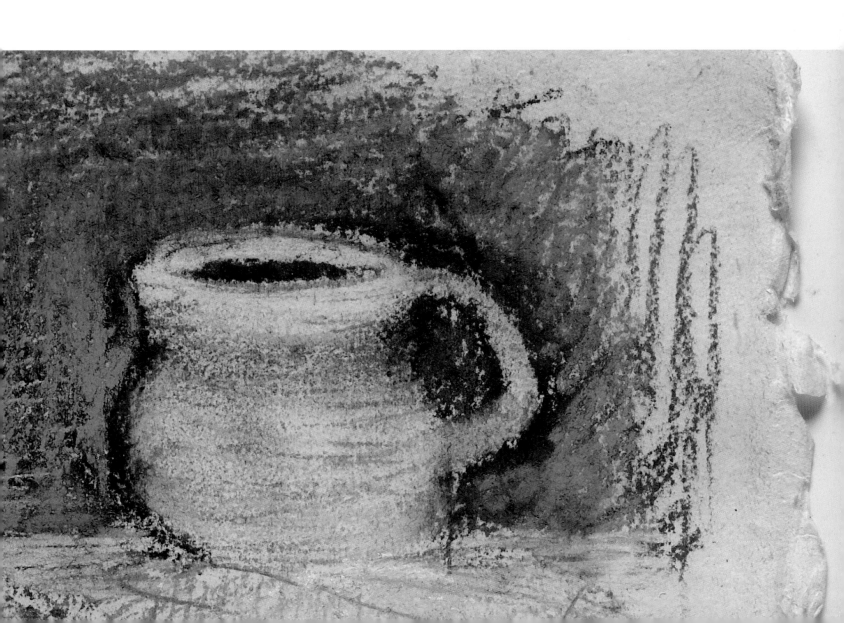

Con-tents

introduction

a strictly hands-on technique

There are people who still believe that painting with pastels is a technique for beginners and that it is not much different from the "coloring" done in grade schools. The precious boxes of pastel sticks that are sold in art supply stores certainly remind us of boxes of crayons, but the similarity ends there, because pastel painting is a technique that is as demanding (or as fun, according to your point of view) as any other. Professional pastel artists work with a greater number of different colors than other artists, sometimes even in the hundreds. Some of the most prestigious manufacturers of pastels offer more than 1,000 different colors in their catalogs to satisfy each and every artist's needs by giving them exact tones. This should be enough to disavow the label of *amateur*, who would use only the most limited boxes of colors.

This book is for those who want to learn to paint with pastels as well as for experienced pastel artists. In these pages you will find lessons that range from manufacturing your own pastels to the keys to chromatic harmony, and all kinds of techniques and practical advice. A detailed study of the materials of the pastel artist is also here, as well as suggestions about which may be the best choices for the beginner. Finally, we offer extensive practice with many examples, for all the typical subjects of the pastel artist, in a wide range of styles and interpretations.

There is no difference between drawing and painting when working with pastels. That is one of the main attractions of this technique for artists who want direct and uncomplicated expressiveness.

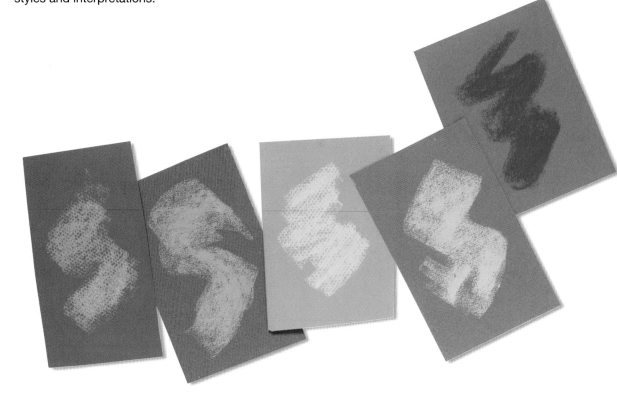

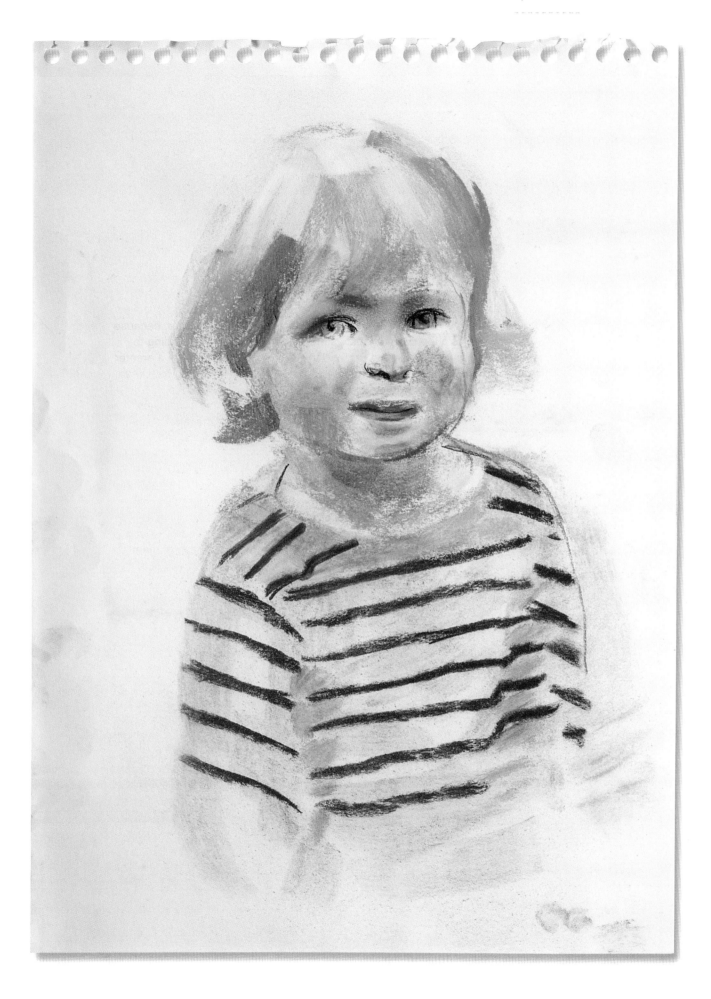

The Pastel Artist's Materials

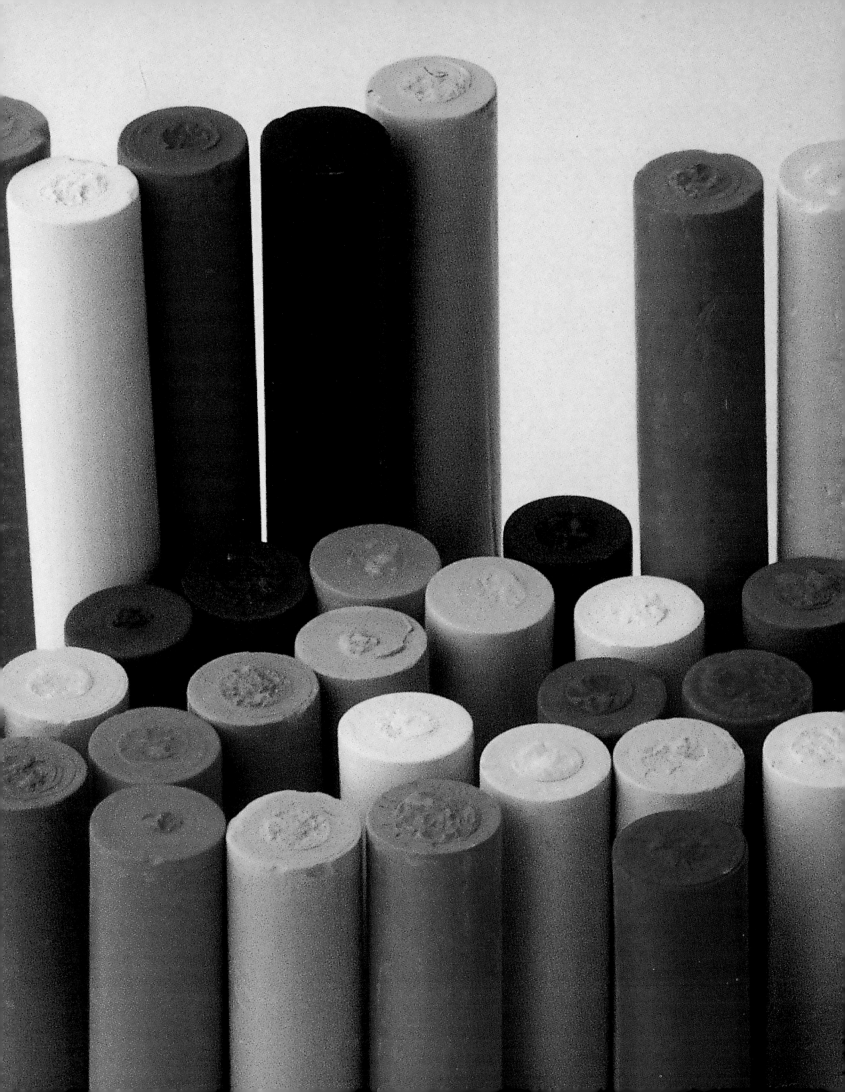

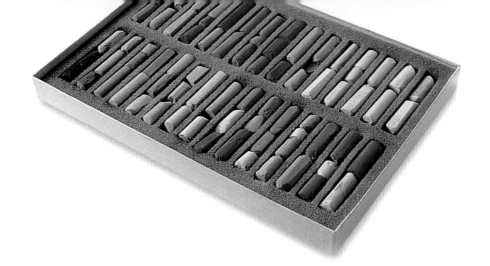

Pigments, Paints, and

Colors of Pastels.

Pastels in different forms and denominations

have been used since the Renaissance;

however, the multicolored sticks that come to mind when we think of pastels did not appear until the eighteenth century, thanks to the Italian portraitist Rosalba Carriera (1675–1757). The composition of the pastel sticks has changed very little since then. They are made with a specific amount of pure pigment formed into a stick with water and natural or synthetic gum as an agglutinate. This basic composition makes pastels the painting medium that is closest to pure pigment.

Composition and Qualities of Pastels

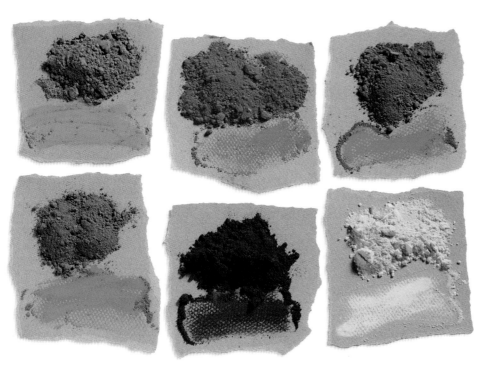

Pigments are colored powders of mineral or synthetic origin that are used for manufacturing paint. Pastels are the closest medium to pure pigment.

Pastels are almost pure pigment. Pigments are colored powders made from ground minerals and also from chemical compounds. The former are inorganic pigments, most of them known to the classical painters. The latter are organic, and the majority of them are no more than 150 years old. Pigments are used to make paint: oil paint, watercolors, pastels, and others. And colors are the peculiar sensations produced by the pigments and paints that are known as red, green, blue, pink, yellow, and so on.

PASTELS AND PIGMENTS

Painting with pastel sticks is as close as you can get to working with pure pigment. Other painting techniques require a vehicle or medium (oil for oil paint, gum arabic in watercolors, and acrylic emulsion in the paint known as acrylics); pastels, on the other hand, are pure dry pigment that is barely held together with a very light gum as a binder or agglutinate, just enough to maintain the consistency of the sticks. Still, high-quality pastels crumble easily, even inside their wrapper, because of the large amount of pure pigment they contain.

Manufacturers mix the pigments to create all the shades of color used to make pastel sticks.

Crumbled pastels leave the pure pigment (or mixture of pigments) that they are made of. In addition, the sticks usually have a varying amount of calcium carbonate, a white powder that adds body without affecting the color.

Sometimes you will find pastels that are really chalk, sticks of plaster that are tinted with dye. These are fine for schoolwork, but they are not acceptable art materials. They do not adhere well, and they fade very quickly.

PIGMENT QUALITY

The best pastels are made from high-quality pigments, either alone or mixed with each other to create other colors. The purity of the pigment in a pastel can be ascertained by submerging a piece of it in water. It will dissolve and cloud the water, but after a short while all the pigment will settle on the bottom of the container and the water will become clear again. If we decant the water, we will be able to collect all the pigment that was contained in the pastel stick. Pigments are insoluble and contain neither dyes nor colorants, substances that stain the water and whose color will fade over time.

Extra-soft pastels can crumble easily when they are used, even when they are still in their sleeves.

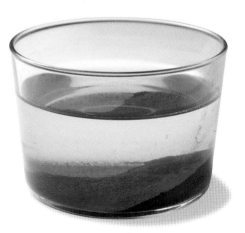

If the pastel has only high-quality pigment, it will settle to the bottom and the water will be clear.

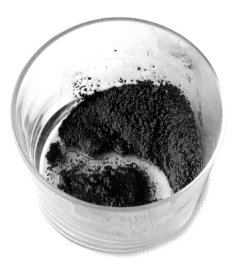

If the water is decanted from the container, all the pure pigment can be recovered from the dissolved pastel.

The conventional pastel is a thick stick of dry color wrapped in a protective paper sleeve. Fine-art material suppliers also sell thinner and much harder sticks, as well as pencils with leads that are similar to pastels but much harder. These variations are very popular and are sometimes a necessary addition to the pastel artist's work.

Forms and Varieties

SOFT PASTELS

Soft pastels come as round sticks about ⅜ to ⅝ inches (10 to 15 mm) thick and 2⅜ to 3¼ inches (6 to 8 cm) in length, but there are also half sticks and extra-large sticks. They are available individually or in boxes of assorted colors. The range of colors is usually very large, and each pastel artist works with his own selection of colors based on the nature of the subject matter, personal style, and the artist's experience with the medium. The softness of the sticks varies according to the manufacturer and the pigments used in them. Some green and carmine pigments require much more agglutinate than other pigments, which results in harder sticks. It is not a good idea to buy sticks whose ends are crumbled and broken, indicating that they are excessively soft.

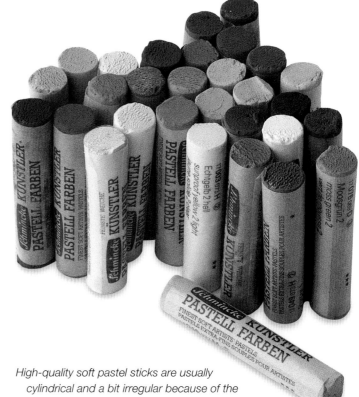

High-quality soft pastel sticks are usually cylindrical and a bit irregular because of the different consistency of each pigment. They may be slightly chipped as a consequence of their softness.

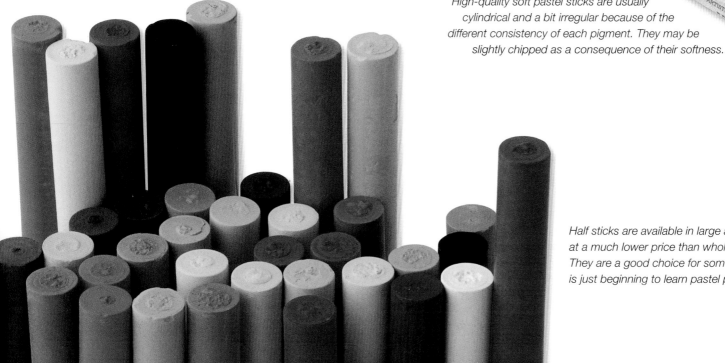

Half sticks are available in large assortments at a much lower price than whole sticks. They are a good choice for someone who is just beginning to learn pastel painting.

HARD PASTELS

Hard pastels sticks are thinner and usually square, and the selection of colors is very limited. They are much harder than traditional pastels because of the way they are baked during the manufacturing process. The pigment is agglutinated with one part clay, which adds rigidity to the sticks. They are often used as a layout and drawing medium in the first phases of the work because they can be used to make more or less fine lines and hatching. Some artists refer to this type of pastel as *chalk*.

There are very large sticks available for making large-format paintings. They are also very useful for medium-format work, because they can lay down color quickly without throwing off bits and pieces of the stick like smaller ones would.

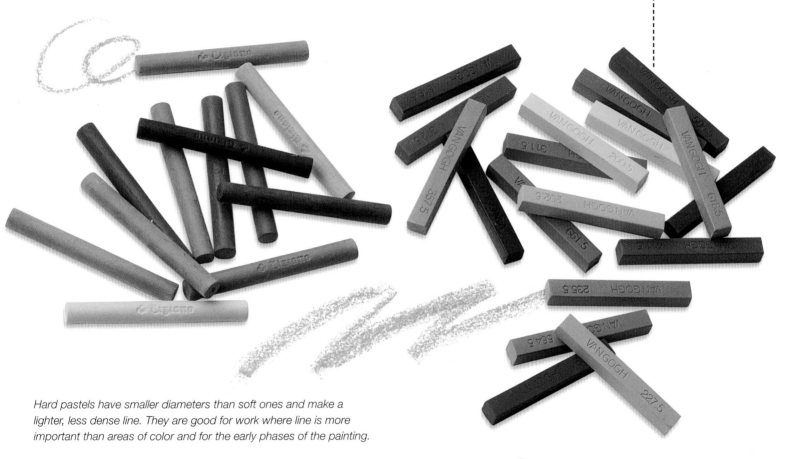

Hard pastels have smaller diameters than soft ones and make a lighter, less dense line. They are good for work where line is more important than areas of color and for the early phases of the painting.

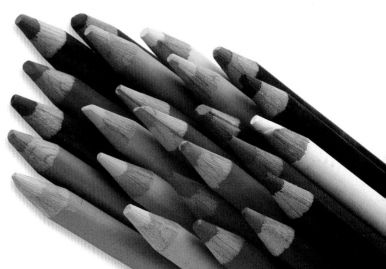

Pastel pencils are an ideal choice for small-format work and for adding detail to paintings made with soft pastels.

Color Ranges

Pastel artists can choose their colors from among the largest range imaginable. Not only is the selection of colors large, but so is the number of different shades of the same color. This is because pastels do not mix well on the support, and a clean tone is difficult to create with two colors. For this reason manufacturers create lighter and darker tones of each pigment and each mixture of pigments. This increases the options, and the larger manufacturers offer dozens and sometimes hundreds of different colors.

INDIVIDUAL STICKS AND SETS

The sets that are sold by different companies are usually a good choice for beginning pastel artists. The color selections run from 20 to 50 different colors, without too many intermediate shades. This means that artists will soon need specific colors to adapt the set to their way of working. This problem can be resolved, at least partially, without spending too much money by buying large sets of half sticks, because the selection is much greater and the prices are not excessive. The shorter length of the stick does not present a problem when working, because most pastel artists break their sticks in half so they can control them better anyway. With time artists will get a better sense of their needs and begin to acquire their pastels one at a time.

Color charts from the major manufacturers have extensive color ranges from which the painters can choose the pastels that best meet their requirements.

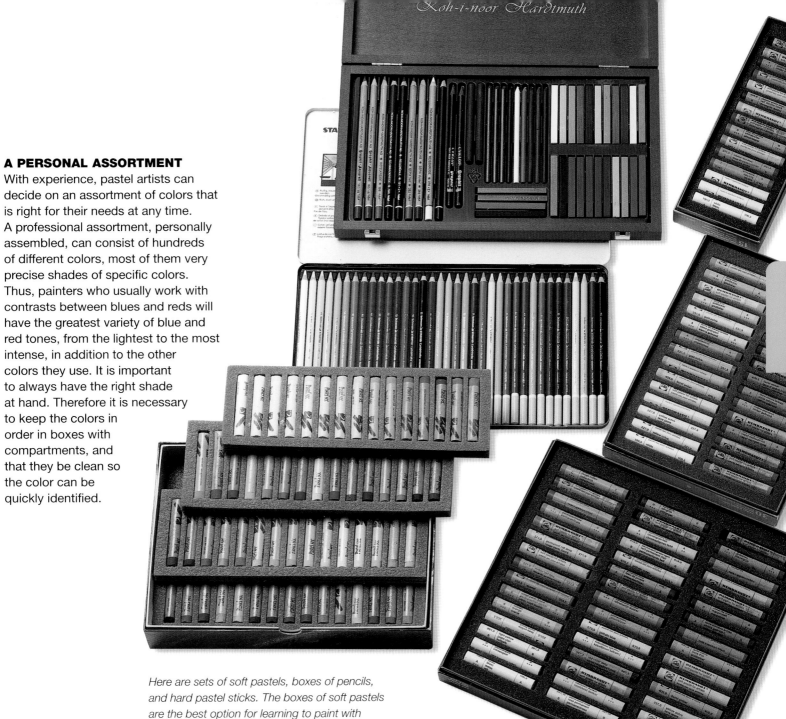

A PERSONAL ASSORTMENT

With experience, pastel artists can decide on an assortment of colors that is right for their needs at any time. A professional assortment, personally assembled, can consist of hundreds of different colors, most of them very precise shades of specific colors. Thus, painters who usually work with contrasts between blues and reds will have the greatest variety of blue and red tones, from the lightest to the most intense, in addition to the other colors they use. It is important to always have the right shade at hand. Therefore it is necessary to keep the colors in order in boxes with compartments, and that they be clean so the color can be quickly identified.

Here are sets of soft pastels, boxes of pencils, and hard pastel sticks. The boxes of soft pastels are the best option for learning to paint with pastels; starting with this, an artist can begin to create a personal assortment by buying more pastels one at a time.

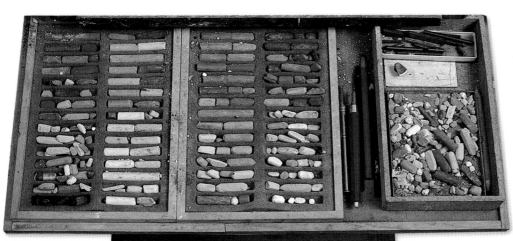

All pastel artists have their own way of storing their pastels. This box allows the big sticks, the small sticks, the small pieces, the charcoal, the chalk, and even some pencils to be stored separately.

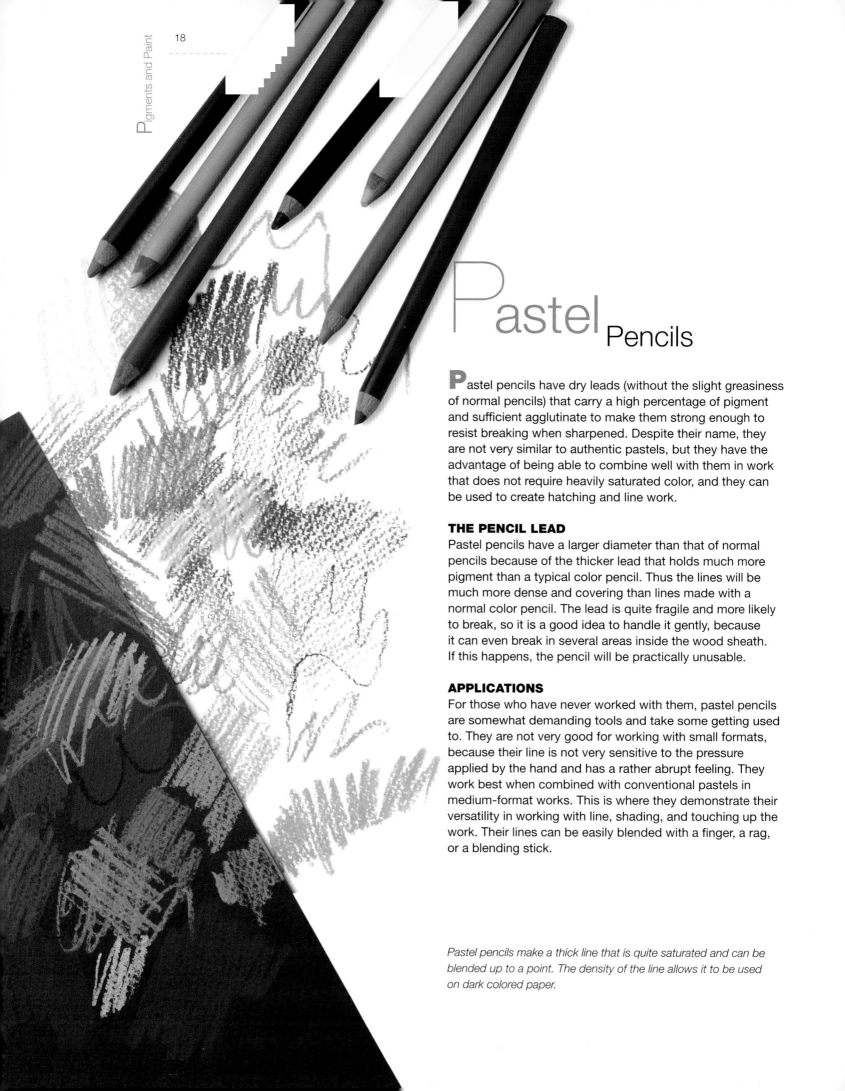

Pastel Pencils

Pastel pencils have dry leads (without the slight greasiness of normal pencils) that carry a high percentage of pigment and sufficient agglutinate to make them strong enough to resist breaking when sharpened. Despite their name, they are not very similar to authentic pastels, but they have the advantage of being able to combine well with them in work that does not require heavily saturated color, and they can be used to create hatching and line work.

THE PENCIL LEAD

Pastel pencils have a larger diameter than that of normal pencils because of the thicker lead that holds much more pigment than a typical color pencil. Thus the lines will be much more dense and covering than lines made with a normal color pencil. The lead is quite fragile and more likely to break, so it is a good idea to handle it gently, because it can even break in several areas inside the wood sheath. If this happens, the pencil will be practically unusable.

APPLICATIONS

For those who have never worked with them, pastel pencils are somewhat demanding tools and take some getting used to. They are not very good for working with small formats, because their line is not very sensitive to the pressure applied by the hand and has a rather abrupt feeling. They work best when combined with conventional pastels in medium-format works. This is where they demonstrate their versatility in working with line, shading, and touching up the work. Their lines can be easily blended with a finger, a rag, or a blending stick.

Pastel pencils make a thick line that is quite saturated and can be blended up to a point. The density of the line allows it to be used on dark colored paper.

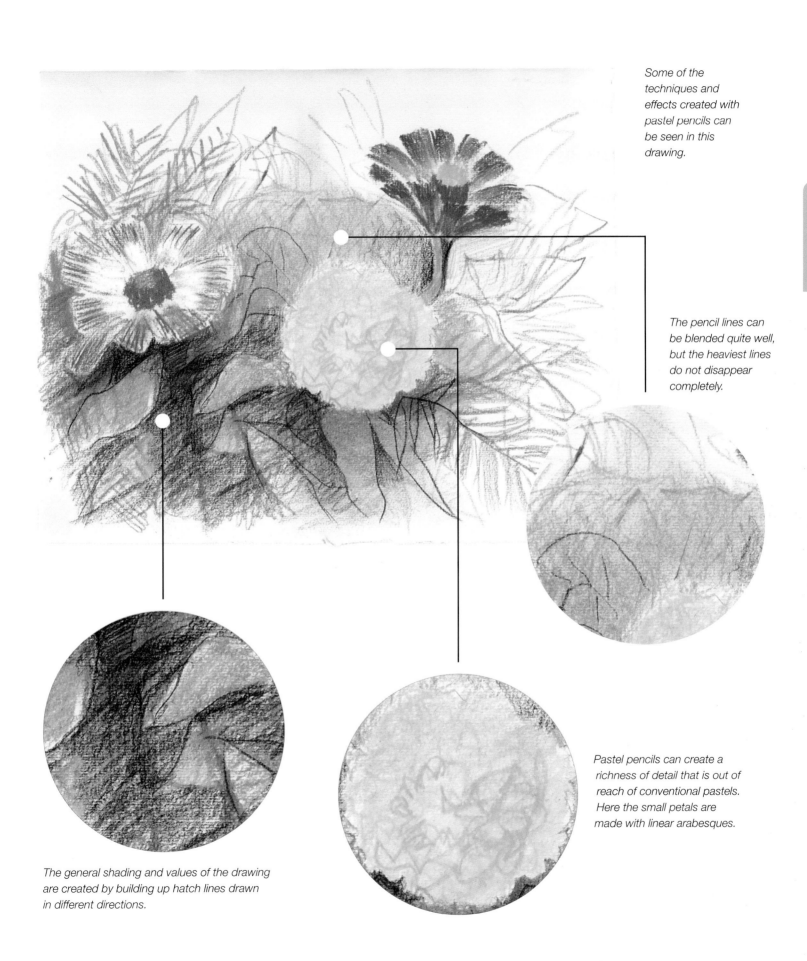

Some of the techniques and effects created with pastel pencils can be seen in this drawing.

The pencil lines can be blended quite well, but the heaviest lines do not disappear completely.

The general shading and values of the drawing are created by building up hatch lines drawn in different directions.

Pastel pencils can create a richness of detail that is out of reach of conventional pastels. Here the small petals are made with linear arabesques.

Handmade Pastels

Artists who choose to make their own pastel sticks will not find it very difficult. There are two advantages to making them: It is possible to make desired colors by mixing the pigments oneself, and the length and thickness of the sticks can be varied. There are also two disadvantages: Making them requires a considerable amount of time, and it is necessary to experiment to eventually arrive at the correct proportions of all the ingredients.

MAKING THE AGGLUTINATE

Tragacanth gum is a natural resin obtained from *Astralagus gummifer*, a common plant in the desert regions of Africa and the Middle East. It can be acquired at some art supply shops and on the Internet in the form of a very fine, light ochre-colored powder. It is not water soluble, but it forms a viscous emulsion in small concentrations, which means that a small amount of powdered gum is enough to make a large amount of agglutinate. The rule of thumb for the proportion is two spoonfuls of gum for each half quart of distilled water. The emulsion should be left to rest for one or two days in a closed container until the mixture becomes a light gel.

Tragacanth gum is a very fine powder that emulsifies with water. A small amount can generate a large amount of emulsion.

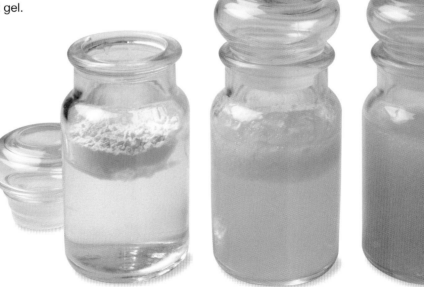

The gum is left to soak in water in a closed container for one or two days, until the entire volume of water is of equal consistency.

KNEADING AND BINDING THE PIGMENT

The agglutinate should not be mixed with the powdered pigment until the powder has been converted into a paste by mixing it with distilled water. Since it is very difficult to create a paste with the pigment by simply mixing it with water, a few drops of alcohol can be added to it. Properly kneaded pigment is agglutinated or bound by pouring a small amount of tragacanth gum emulsion over it. Then the mixture is mixed with a flexible spatula to obtain a paste that has a texture similar to clay. The amount of gum will depend on the amount of pigment; it is best to add a few drops and then knead them, and to repeat this operation until achieving the desired pasty texture and completely mixing the pigment and agglutinate.

A small amount of calcium carbonate (Spanish white) is usually added to pure pigment pastes to add smoothness to the lines drawn with pastel sticks.

1

2

3

1. The pigment is first mixed with water to create a paste. A few drops of alcohol can be added to make them easier to mix.

2. Gum is added to the color mixed with water in enough quantity to create a creamy consistency.

3. The paste must be mixed repeatedly with a flexible spatula until it can be kneaded by hand like a piece of damp clay.

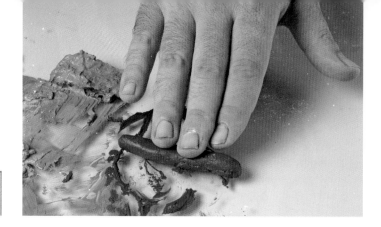

Forming the Sticks

The pastel sticks are formed by using the fingers to roll the paste until it is the proper thickness. If the agglutinated pigment is too sticky, you will have to wait a while for it to dry a little and become easier to handle. The agglutinated cakes of pigment can be cut into pieces of different length according to the wants and needs of the artist. The sticks are finally left to dry on absorbent paper (a newspaper, for example). In warm and dry environments it is a good idea to cover them with waxed paper to slow their drying and avoid cracking.

MONOCHROMATIC RANGES

When manufacturing pastels, the pigments can be mixed with each other to make sticks of particular colors. The artist can not only fabricate the colors to his or her taste, but can also make lighter and darker tones derived from a single color. Starting with any color it is possible to create two or three lighter shades by mixing the pigment with progressively greater amounts of white pigment. In the same manner, the original color can be mixed with different amounts of black pigment to achieve dark shades.

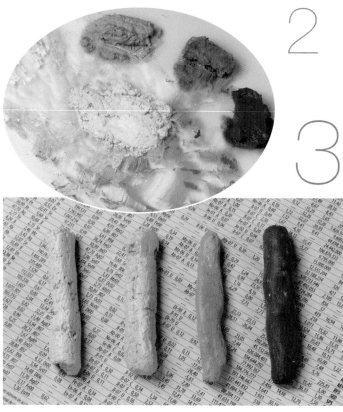

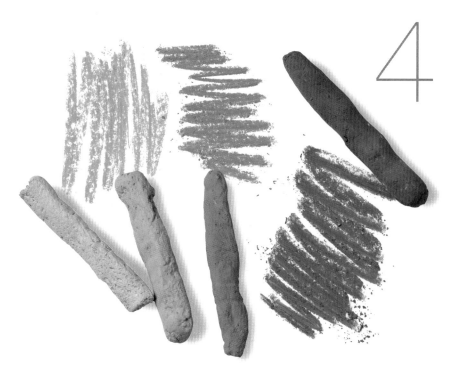

1. The agglutinated pigment paste is formed by rolling it with the fingers. The thickness and length of the stick are up to the artist.

2. It is a good idea to manufacture different shades of each color by mixing them with increasing amounts of white pigment. Conversely, the color can also be mixed with varying proportions of black pigment.

3. The formed sticks are left to dry for one or two days on a newspaper. If the environment is very warm, they can be covered with waxed paper to slow down the drying time.

4. If the process has been carried out correctly, the dry sticks will be top-quality painting materials.

These are handmade pastel sticks. The different surface textures vary according to the pigment that is used, whether or not white pigment was added, and the quality of the agglutinate.

Pastels vary in hardness according to the manufacturer. The handmade sticks (in the image at left) can be very soft, and lay down a heavy, continuous color.

THE CORRECT HARDNESS

It is possible that the sticks will crack or even break when they dry. If this happens, it means that the agglutinate was either too light or there was not enough of it. If they keep their shape but crumble excessively when they are used, it will be for the same reasons as before but to a lesser degree. If, on the other hand, they scratch the paper or do not leave a dense, rich line of pigment, it means that they have too much agglutinate. Not all pigments require the same amount of agglutinate, and the amount that is correct for some colors will be too much or not enough for others. Only trial and error will allow you to establish the correct amount for each color.

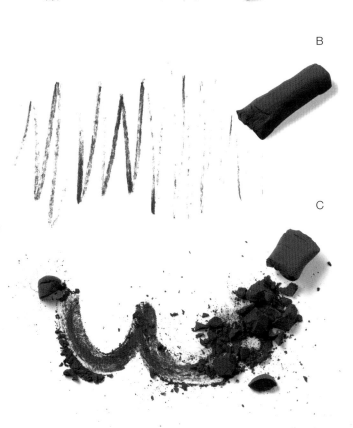

A

B

C

The line made by the stick should be soft, dense, and continuous, and not show any roughness (A). Excessive agglutinate creates a stick that makes hard, rough lines that scratch the paper without leaving pigment on it (B). Too little agglutinate causes the stick to crumble as soon as it is applied to the paper (C).

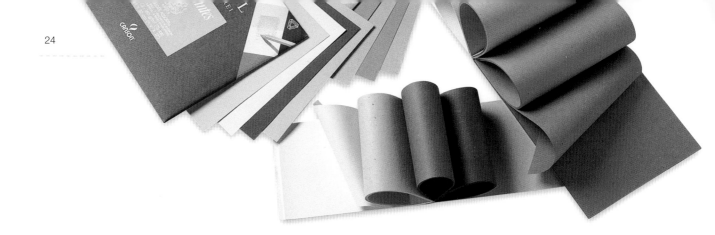

Paper and Other

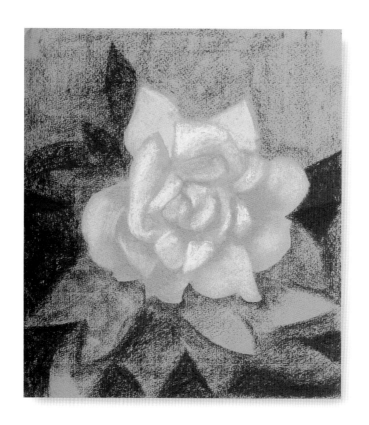

Supplies.
Because it is the most direct

of the painting media, pastel painting barely requires more than the sticks and a support. The support, generally paper, becomes very important. Pastel artists continually experiment with new papers to see how the texture and consistency of the surface can enhance their artistic intentions. There are some other accessories to consider, which will be shown on the following pages.

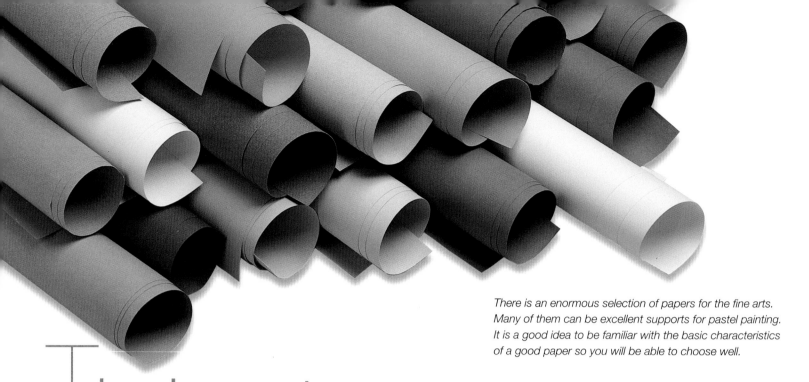

There is an enormous selection of papers for the fine arts. Many of them can be excellent supports for pastel painting. It is a good idea to be familiar with the basic characteristics of a good paper so you will be able to choose well.

The Importance of the Paper

Together with the pastel sticks, the paper is a crucial factor in the final result of a pastel painting. The surface of the support affects the working process and the final piece. Papers that are appropriate for pastel painting should have a certain roughness to retain the pigment. Thus, papers that are too smooth are not adequate, because the pastels slip across them and it is impossible to cover the surface with color. Among the high-quality papers, each manufacturer offers different surfaces, and it is up to artists to choose the one that works best for their style.

TEXTURE AND FINISH

The rougher the texture of the paper, the more pigment it will hold, which results in greater color saturation. On the other hand, paper with a lot of texture makes a smooth stroke more difficult and hinders the creation of defined outlines in the areas of color. Smoother papers are easier to work with and render a cleaner outline and finish.

TWO SIDES OF THE PAPER

Almost all high-quality papers have a different texture on each side. The difference may be more or less pronounced, but it will be clearly perceptible as soon as the surfaces are painted. The artist should be aware of the differences and make some tests before going to work, because there is no objective way of telling whether one side may be more appropriate than the other. Some pastel artists prefer very regular surfaces (with a repetitive texture), and others opt for irregular drawing surfaces.

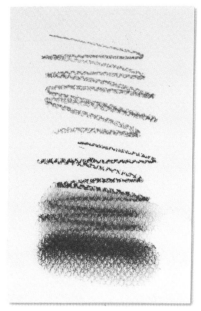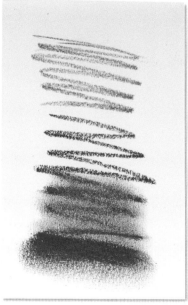

These two scribbles were made on both sides of the same paper (Canson Mi-Teintes paper, the most popular among pastel painters). The finishes are different: One is more textured, and the other is much smoother.

Following page. This work was made on six different pieces of paper. Each one of them has a distinct texture that produces different finishes. Comparing them with one another will give us an idea of the distance between a smooth paper and one that is very textured, and show us what finishes to expect from each one.

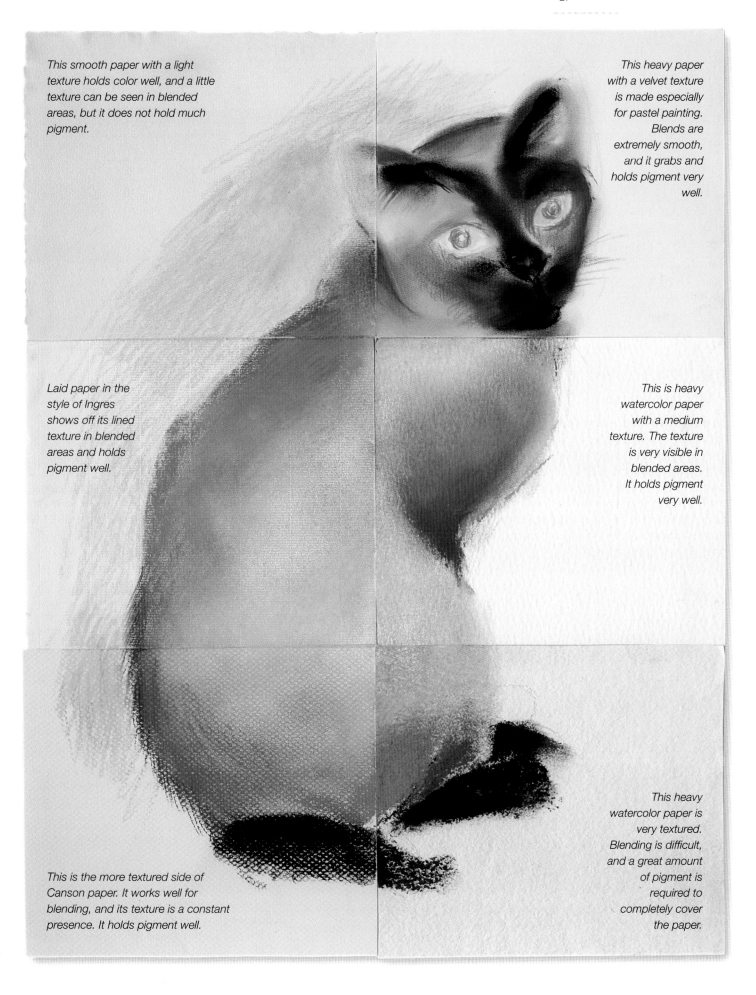

This smooth paper with a light texture holds color well, and a little texture can be seen in blended areas, but it does not hold much pigment.

This heavy paper with a velvet texture is made especially for pastel painting. Blends are extremely smooth, and it grabs and holds pigment very well.

Laid paper in the style of Ingres shows off its lined texture in blended areas and holds pigment well.

This is heavy watercolor paper with a medium texture. The texture is very visible in blended areas. It holds pigment very well.

This is the more textured side of Canson paper. It works well for blending, and its texture is a constant presence. It holds pigment well.

This heavy watercolor paper is very textured. Blending is difficult, and a great amount of pigment is required to completely cover the paper.

Today many pastel artists use heavily textured papers to emphasize the presence of the pigment on the support, and put less emphasis on creating a realistic work of art. The heavy texture actually hinders a naturalistic interpretation of the theme and encourages applications of impasto, accumulations of color that do not define the form well. Fine-grained sandpaper is one of the possible choices for a support of this type, as are prepared wood supports and handmade papers.

Heavily Textured Supports

PREPARING THE SUPPORTS

With the proper preparation, many different supports can be used for pastel painting. Wood is the most obvious choice. The surface of the wood is prepared with a coat of acrylic primer that is applied with wide, irregular brushstrokes to emphasize the texture. There are acrylic preparations specifically made for pastel painting that incorporate pumice particles in suspension that create an excellent texture for the pigment.

Sandpaper is not a very common support, but it is effective if the fine-grained varieties are used. It holds a great amount of pigment, but it is impossible to outline the shapes.

It is possible to prepare some supports (like wood panels) by applying an acrylic preparation with large irregular brushstrokes to emphasize the texture.

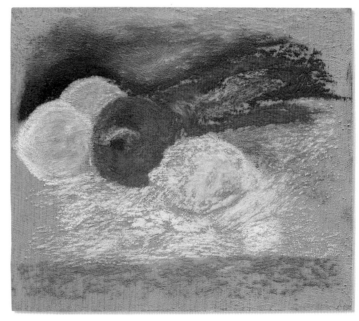

This painting was done on a wood panel with acrylic primer. The texture is very heavy and irregular.

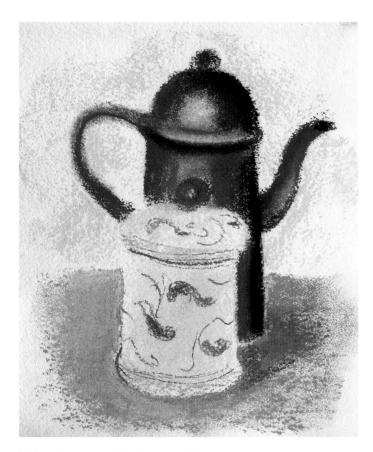

Watercolor paper with a heavy grain has a very rough texture that is difficult to cover with the pigment. The results are crude but very lively because of the saturated color.

HANDMADE PAPER

Handmade papers are manufactured one sheet at a time with irregular deckled edges on all four sides. They typically have a heavy texture and are quite irregular and spongy, which makes them very absorbent. This absorbency makes it difficult to achieve even, delicate blending, and the heavy texture encourages the accumulation of pigment. The finishes are rough and abrupt and highlight the material qualities of the technique while hindering attempts at realistic representations.

Heavily textured papers are difficult to cover completely; the grain almost always shows through the pigment. This effect is desired by artists who like to emphasize the primary qualities of the art materials.

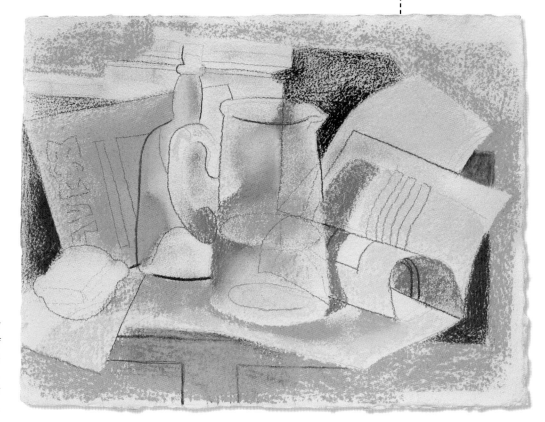

Artisanal handmade paper offers pastel artists many possibilities as a support if they desire rustic-looking work, where the colors do not follow tightly defined edges. The heavy texture creates a different feeling and great warmth.

The Color of the Paper

There is no technical reason that keeps us from using white paper, but light colors do not stand out on it very well, and that can often be a problem. Colors will naturally integrate on a paper whose color is similar to the general tone of the work, and areas can be left unpainted, with the knowledge that the color of the paper will look like one more color in the artwork rather than a "hole" in it. In addition, the color of the paper itself will highlight, through contrast, the various applications of pastel.

COLOR RANGES

The most popular paper colors used by pastel artists are the light siennas and ochres, as well as grays of various intensities. These soft tones that are more or less warm or cold usually harmonize well with all subjects and color ranges, light and dark grays with blue or green tendencies, raw sienna, different shades of ochre, ivory tones, neutral earth tones of varying

intensities, and so on. Some selections include papers of all colors, from white to black, passing through a wide range of blues, reds, yellows, carmines, oranges, and greens of diverse intensities and saturation. The papers are sold in the most common size of 19½ × 25½ inches (50 x 65 cm), but they are also available in pads of various sizes, packs of loose sheets of the same color, and even in rolls.

CHOOSING THE COLOR

As a general rule, you should choose a paper with a light tone when you wish to use dark and dense colors, because they will stand out and are easier to see on a light surface than on a dark one, and the colors will look richer because of the contrast. A paper with an intermediate tone is useful for subjects that will be painted using the lightest to the darkest color ranges—in other words, using all the possible colors.

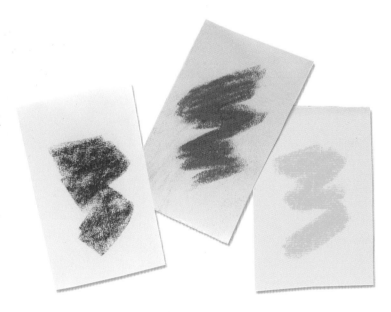

The papers most commonly used by pastel artists are not white, but those of raw colors like cream, pink, and ivory. These papers help us see the contrasts and harmony of the colors.

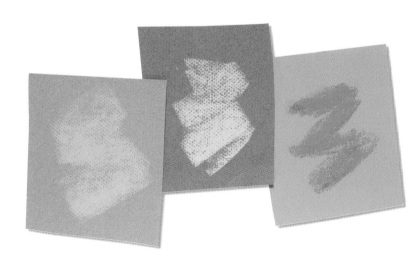

Gray papers in the cool range (blue and green) are good supports for work using the same cool color ranges.

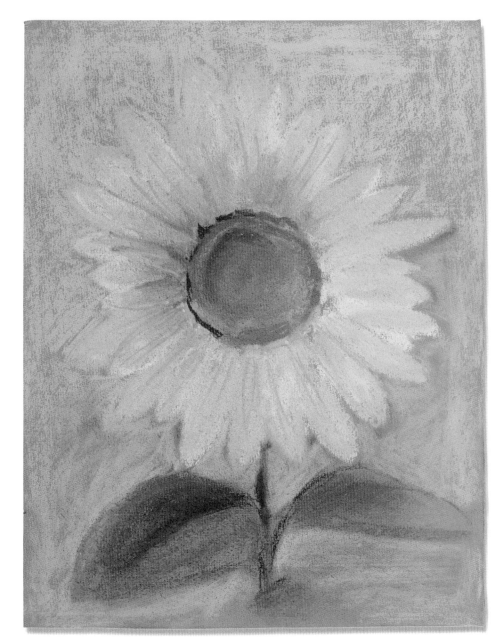

Very bright colors require intense, even exaggerated contrasts for harmony in the artwork. It is interesting to experiment with these colors because you will be forced to focus on your chromatic creativity.

This work was painted on a greenish paper with a warm tendency. The color of the background is covered by the accumulations of yellow, but the background can be seen between the strokes.

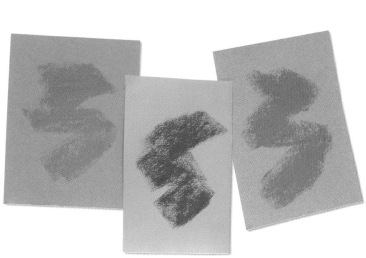

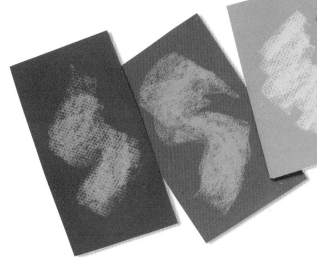

Work done using warm colors should make use of supports with gray tones with warm tendencies such as red and brown.

Bright colored papers require work done with colors that are equally vibrant so the support will harmonize with the art piece.

Painting on Very Dark Paper

It is not very common to use dark paper supports; however, the work resulting from using them is interesting, and they deserve to be mentioned. Dark paper works well for subjects that show a strong contrast in light. The light colors stand out more strongly and the dark colors seem darker when they are applied to the background color. The color of the paper can be allowed to show through the pastel color or it can be completely covered. It is a good idea to play with both approaches.

THE PLAY OF COLORS

The background color can be used in two different ways, either to create contrast or to directly participate as a color in the subject matter. If you wish to create very vibrant color effects, you should choose a color that approximates the complementary color of the dominant tone of the work. In other words, in a theme where yellows and oranges are predominant, you should choose a blue paper, and if pink tones dominate, choose a paper with green tendencies. The other way to take advantage of the color of the paper is to choose one whose color coincides with one of the colors in the subject. This way you can paint with just a few colors and the paper will "complete" the work when left unpainted in various areas.

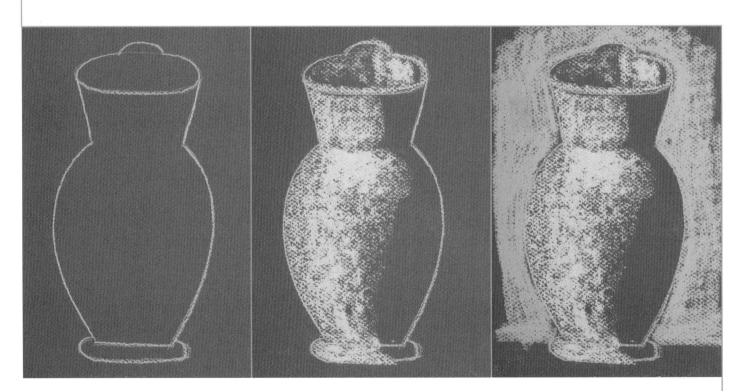

Modeling chiaroscuro forms can be easy when working with very dark paper. The color of the paper is the color of the shadow, so it will be necessary to paint only the lighted area of the object in question.

A very dark support needs several layers of color for the background to be covered. Artists experiment with different amounts of coverage to create contrasts and textures.

This work was painted on a dark brown paper. Both the cast shadows and those on the objects are the unpainted support. The different planes of the composition have colors with different amounts of saturation that cover the background or allow it to show through according to the contrast desired by the artist.

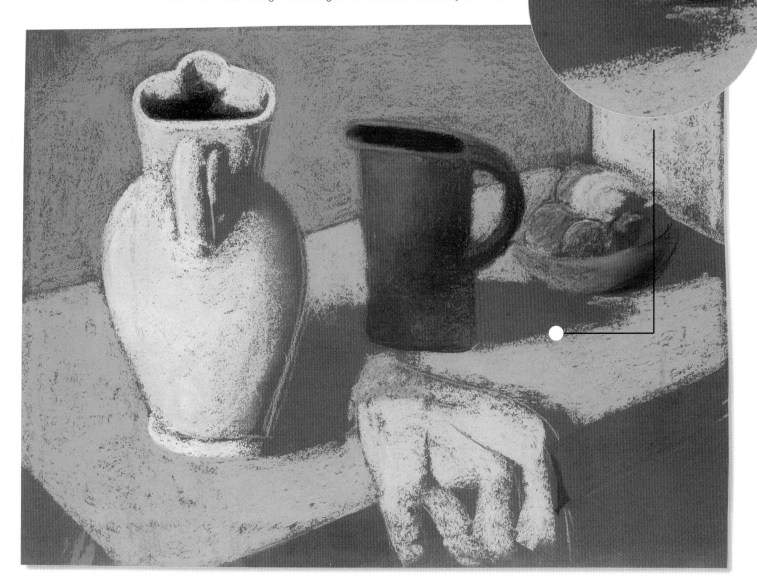

Blending or rubbing a color is as simple as passing your finger across the lines you drew with a pastel stick. You can draw new lines over the blending and then blend it again. This will create a different color, resulting from the blended mix with the first color. This technique can be used at any point in the work to create blends and gradations between one color and another.

Blending: Gradations and Rubbing

HOW IT IS DONE

Blending and fusing colors can be done with a tool other than the hand, such as a blending stick or a rag, but it is more comfortable and appropriate to use the fingers and the side of the hand. The pigment is more easily controlled with the hand, and you maintain a direct contact with the work. The only precaution you must take is to clean the color from your fingers once in a while so you do not dirty the paper. Working like this is more comfortable and your movements are freer, the work is more spontaneous because you are in direct contact with the support, and there is no need to stop to look for any tools. Pastel artists constantly use their fingers, almost as much as the sticks of pastel. Blending sticks can be used in details or smaller works, and rags are used for blending large areas in large-scale formats.

The pastel artist's hand is the basic tool for blending. The fingers, the base of the thumb, and the side of the hand are all incomparable tools for blending and spreading the color.

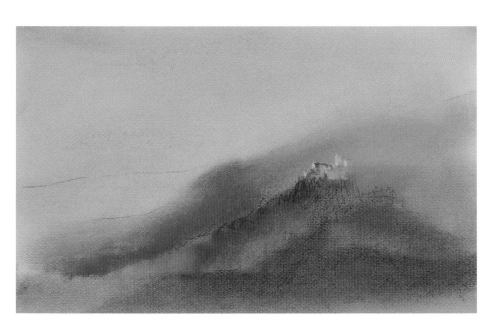

This is the result of a generic blending, which created the effect of a vaporous, foggy atmosphere. All the colors were blended with a rag first, and then with the fingers.

Rags are very useful when it comes to creating large areas of blended uniform color. They should be cotton, and you should avoid applying parts of them that have already been used to the paper.

Blending sticks can be helpful for working on small paintings when there are not many colors, since they tend to become muddy.

The tip of a blending stick charged with color can also be a drawing tool for making lines and outlines.

Basic Blending Processes

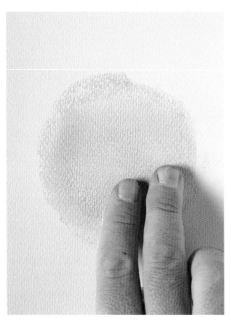

1

2

Blending pastel colors is especially useful at the beginning of the work or when you are working with just a few colors— in other words, when a color has been applied over the clean support and not laid over another. This is the way to achieve very attractive effects of gradation and even colors. On this page we illustrate a simple process for doing this.

APPLICATION AND TREATMENT OF THE COLOR

The blending should be done at the beginning, spreading the areas of applied color across the paper. It is always possible to shade with applications of a new color over the blended areas. These applications should be very light if we want them to mix with the base color through further blending. If the paper is completely covered with pastel color, the blending will muddy the results. This example was blended with the fingers, and after each application the hands were cleaned with a clean rag.

1. The shape is drawn with a piece of pastel stick, using the side against the paper, with no need to make a sketch first.

2. The lines are blended using the fingers, and the color is spread over the entire area chosen for the drawing. The tone of the color is lighter after blending.

3. New colors can be added over the base of blended color to act as shading and to reinforce the shape.

3

4

EXCESSIVE BLENDING

If too many pastel colors are blended, they become unnatural, losing their intensity and characteristic body, and becoming dusty surfaces of washed-out color. This will only become worse if more colors are added. In the end all the colors will have the same tendency and the contrasts will lose their strength. Excessive blending of pastels fills the pores of the paper, penetrating all the irregularities of the texture, and it is very difficult to paint over them with new colors. Remember, pastels demand freshness, and it is not a good idea to make many mistakes with the colors because you will run the risk of ruining the work. If you are not sure about a color, it is preferable to opt for more brightness and purity rather than soft and gray, because it is easier to gray or lighten a strong color than to make a neutral color pure and clean.

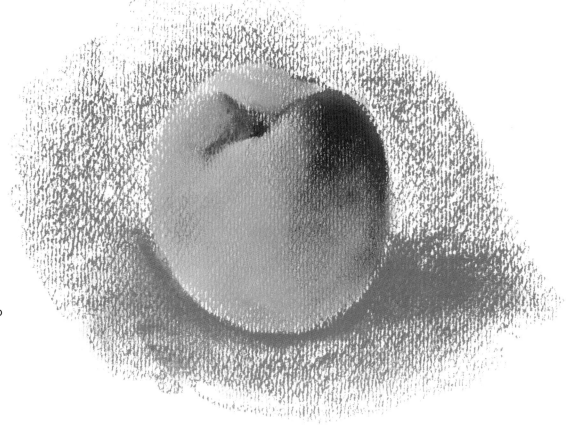

4. Here we added a little light green in the shaded area of the fruit, and then the color was rubbed to blend it with the base color. Some small details and some reddish shadows are enough to finish modeling the fruit.

5

5. Just enough blending was done to rub the red into the yellow and green mass. Finally a contrasting color was added to create a background that highlights the coloration of the fruit.

Erasing and Fixing Pastels

It is difficult to correct or salvage pastel paintings with mistakes or ones that have become impastos. They are fragile and cannot undergo much correcting. The relationship between the pigments and the grain of the paper should be direct and fresh. Excessive erasing will affect the grain of the paper and the adherence of the pigment and destroy the brightness of the final piece. However, at the beginning of the work, and even at advanced stages, it is possible to erase the pigment.

ERASING

Normally a rag or piece of clean cotton is used to rub the pastel to remove it from the paper. You can also remove the pigment with your fingers, and of course with a kneaded eraser. The latter does not damage the texture of the paper, and it allows you to create highlights and return to the background color. It is also possible to use a conventional rubber eraser, which is more aggressive, but it should be used carefully because it can remove the surface of the paper. The rubber eraser can also be a drawing tool, used for drawing light lines on a base of blended color.

The kneaded eraser is very soft and malleable. It absorbs pigment more than it erases it, and it does not damage the paper. It is useful for making highlights in works that have a very thin layer of pigment.

The conventional rubber eraser erases much more than the kneaded eraser, and it can restore all the white of the paper if you first carefully blend all the pastel color to reduce the layer of pigment to a minimum.

The eraser can be used to draw the negative shapes on a base of color. The white lines can be the beginning of a work where you do not have to worry about covering the initial sketch since the sketch is just the white of the paper.

Rubber and kneaded erasers can be used to draw lines on a surface of well-blended color. The first should be used only occasionally, because it can remove the surface of the paper or flatten its texture.

FIXING PASTELS

According to tradition pastel paintings should not be fixed, but there are many differing opinions about this "rule." Today there are some very high-quality fixatives on the market. These are aerosols that do not change the colors and offer the options of glossy and matte finishes. Matte fixatives should always be used with pastels, because pastel paintings naturally have a matte finish. The problem with fixatives—the reason many traditionalists do not use them—is that they alter the color relationships by intensifying and even altering the tones while sometimes destroying the freshness of the lines. This is especially true if several layers of fixative are applied. The solution is to apply a very fine layer of fixative, and then adjust the colors that are seen to be most altered. Another solution is to fix the different layers of color as you work, leaving the final layer without fixative.

REPAINTING

If you wish to paint one color over another that is already fixed without mixing the tones, you can fix the first color and draw over it without any problem. You can even blend the second color or erase it to return to the first color, because the fixative creates a texture that the pastel adheres to well.

The left side of this color was fixed before blending. The fixed half resists the rubbing of the rag, whereas the pigment that was not fixed is spread over the paper.

Light areas can be easily colored over (A); when the color is more saturated, the color on top does not cover the lower one well because the latter has filled all the cavities of the texture and the pigment is not able to adhere to the paper (B). After fixing an area of saturated color, the pastel will be able to adhere to the dry film of the fixative and thus cover the base color (C).

A B C

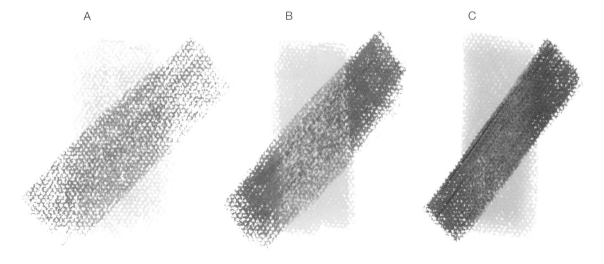

Basic Techniques for

Painting

with

Pastels

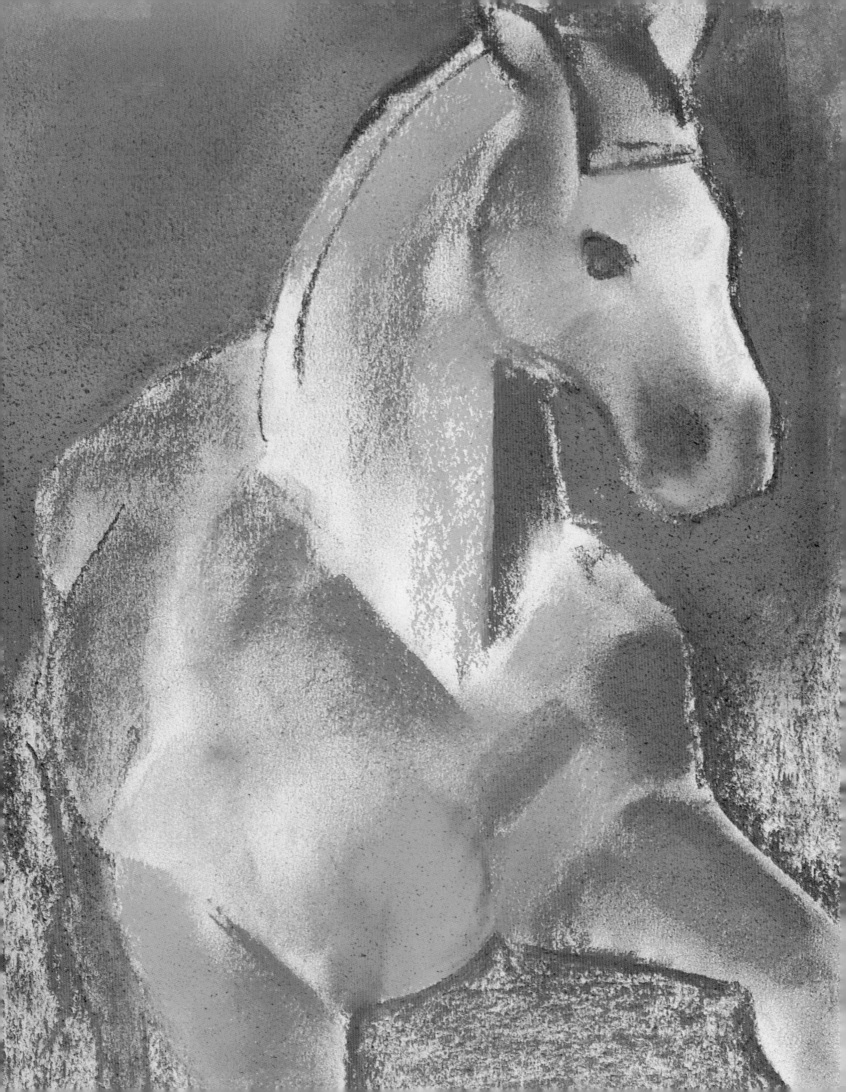

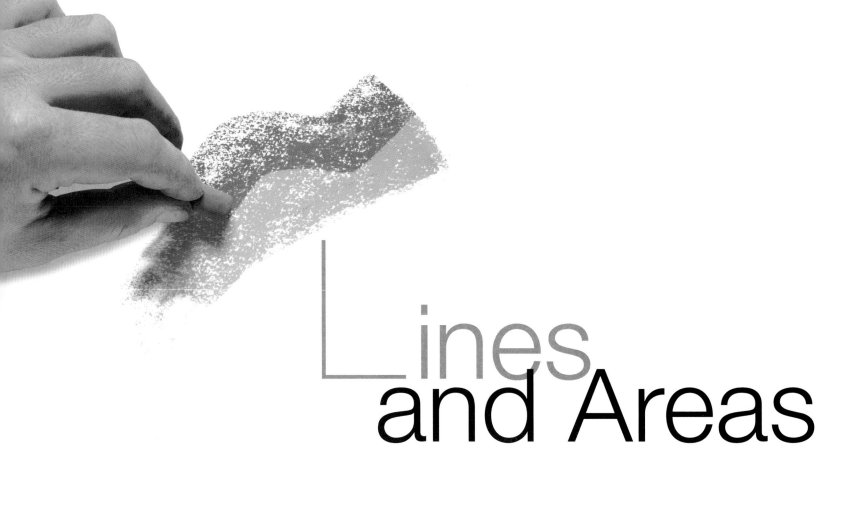

Lines
and Areas

DAVID SANMIGUEL. SLEEPING CAT, 2007. *PASTEL ON PAPER.*

of Color.

No matter how cold and distant

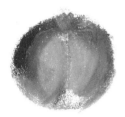

the style of an artist, the spirit that moves him is not represented exclusively by the subject of the work. Whether it is an ambitious work or a humble sketch, there is always an artistic intention that is reflected in the choice of how to make it. In the art of pastels, these choices in the interpretation translate to the alternatives of working with lines or with areas of color, recording the objective data of what is seen, to create a plastic interpretation of the forms, which are the most basic elements of the artistic intentions of the painter.

The Pictorial
Possibilities of Pastels

The background color of this pastel was created by blending, giving it an atmospheric texture. Lines and areas of color were both added over this, using contrasting colors to brighten the colors.

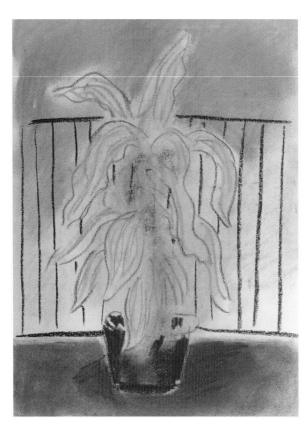

There is no single way of painting with pastels. Because we are dealing with a medium that encompasses aspects of both drawing and painting, the artist can lean toward emphasizing either line work or areas of applied color. Very different results can be achieved from each alternative. And it goes without saying that the ability to blend colors greatly increases the artist's options. All pastel artists combine line, color, and blending in different degrees, but there is always one option above the rest that will unify the work.

LIMITED MEDIA, SUFFICIENT MEDIA

All painting techniques have their limitations, and those of pastels are quite obvious. They do not allow the accumulation of successive layers of pigment, or transparencies and glazing, and great detail is not easily achieved. However, these limitations are totally balanced by the possibilities, which are sufficient for approaching any subject with a personal style. The works reproduced here show the same subject treated in different ways: wide strokes, colors, blending, and drawn lines. These are all typical ways of approaching pastel painting, and they all show different styles, all of them interesting.

Monochromatic work can be an interesting option. The ability of combining different line widths allows us to create a very light and atmospheric version of the subject, made up of drawn lines and areas of color.

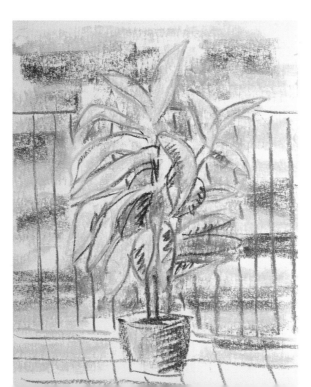

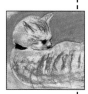

When representing any subject from reality artists should feel like they are handling the pastels with the most possible looseness to achieve fresh and attractive results, whether working with a sketch or making a more ambitious work of art.

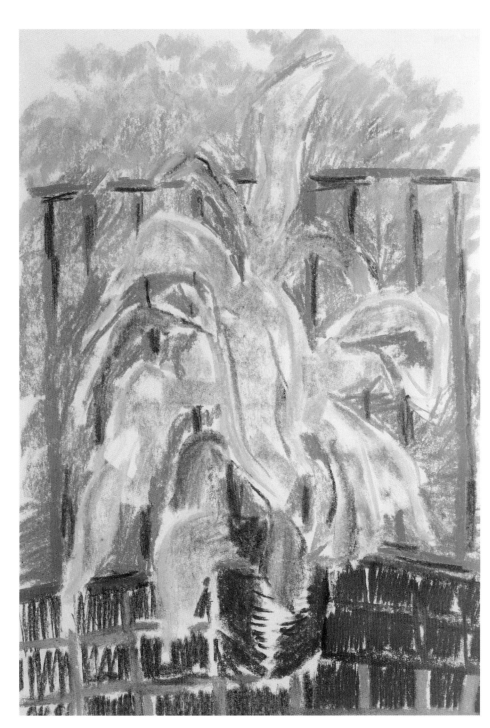

This work rejects any blending to allow the line drawn with the pastel to be the protagonist. Three different blues were used so that the background would not look like a flat surface and to suggest exterior light and atmosphere.

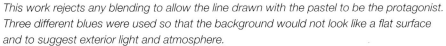

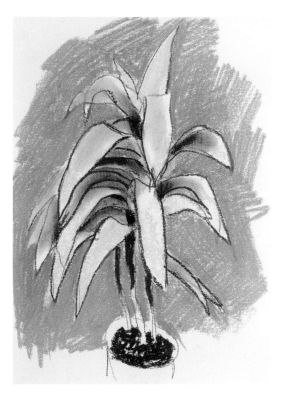

This version looks more like a drawing because of the cursive treatment of the strokes and the character of the line used for the leaves. The leaves contain some light blending to highlight their surfaces.

Form and Color by Combining Hatching

The versatility of pastel is greater than it might seem. The great amount of color in the sticks allows you to use them in very different ways to achieve rich and complex results. One way is painting with lines or hatching. This technique was very popular with great masters of pastel painting such as Degas and Toulouse-Lautrec, and it can be used to create works where the use of lines does not weaken the harmony of the colors.

CROSS-HATCHING

One of the greatest techniques that the artist may learn to use when painting with lines is how to create luminosity when using color. This can be achieved because the lines never completely cover the white of the paper (if the support is white paper), and that white adds light to the combinations and contrasts. On the other hand, the combinations are never made by superimposing colors or blending colors with each other, but by building up lines of different colors in different directions.

The colored lines follow the form. These are alternated yellow and red curved lines that imitate the coloration of the peach.

The linear texture even appears in the lightest parts of the composition. The plane of the tablecloth contains a multitude of pale lines whose angles suggest the perspective.

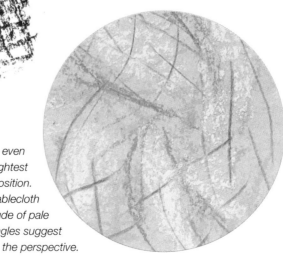

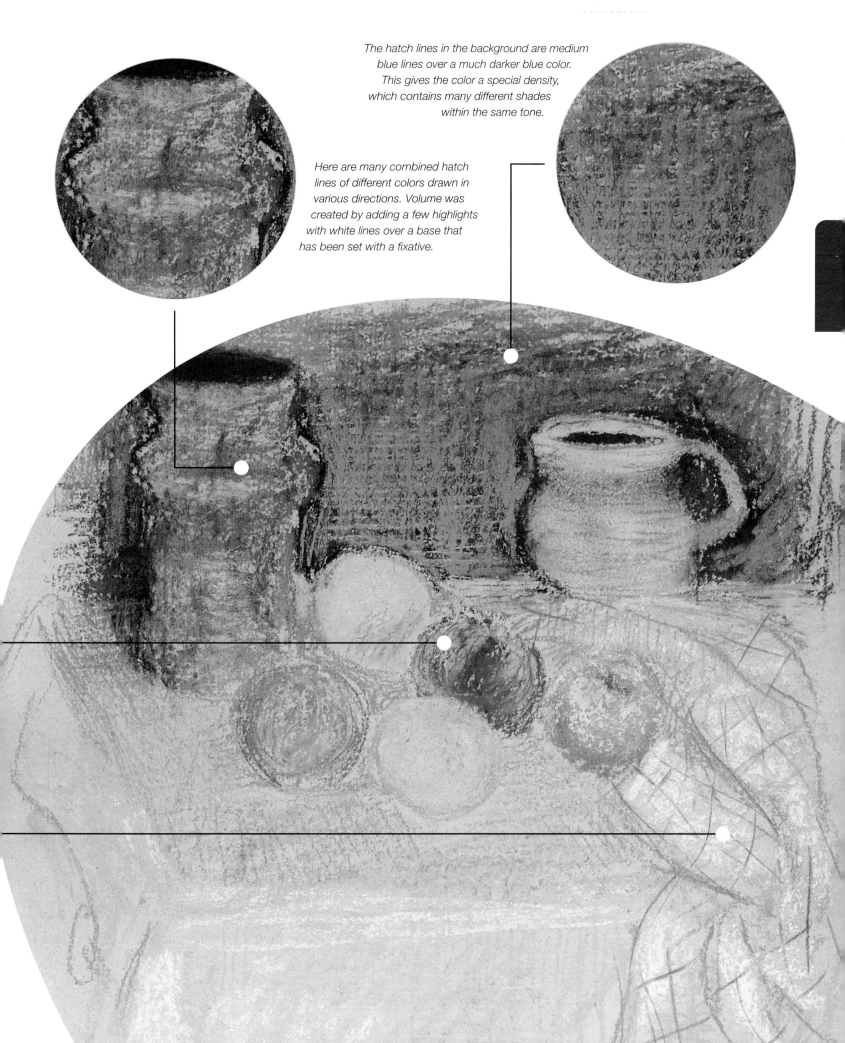

The hatch lines in the background are medium blue lines over a much darker blue color. This gives the color a special density, which contains many different shades within the same tone.

Here are many combined hatch lines of different colors drawn in various directions. Volume was created by adding a few highlights with white lines over a base that has been set with a fixative.

The colored lines of pastels are so saturated and have such an attractive intensity that it is tempting to make only works based on lines, multicolored drawings without blending and without uniform areas of color other than that of the support itself (white or colored paper). The drawing that we show here was done by combining strokes and lines of several colors to suggest the forms by the direction and color of the lines. These drawings should be done in large formats that allow you to easily draw the lines. It is a good idea to practice on brightly colored paper to experiment with the different effects of the contrast between the lines and the tone of the support.

The hair is a combination of yellow, ochre, and green lines. It is the green lines that create the sense of a shaded area (the shadow of the blonde hair) and the hair that is on the darkest part of the head. Alternating these lines helps to express the volume.

Form and Color by Combining Lines

THE COLORS IN THE DRAWING

The key to success in pastel painting based solely on lines resides in freely combining the colors. You must avoid using a single color for the whole drawing or choosing colors based exclusively on realist criteria, since this will result in a lack of creative force.
To avoid creating a flat-looking drawing you can use lines and hatching to indicate volume in the areas of greatest shadow, leaving the paper bare in the most illuminated areas.

The shaded part of the chair consists of perpendicular hatch lines that combine red and blue strokes. The direction of the lines reinforces the feeling of a flat surface, and the contrast between this densely drawn zone and the figure makes it stand out much more.

This is the only part of the drawing where the paper is completely covered, in contrast to the rest of the work. The orange was drawn mainly with yellow and later covered with very dense orange hatch lines. In the rest of the painting the color range is the most vibrant and saturated that this technique will allow.

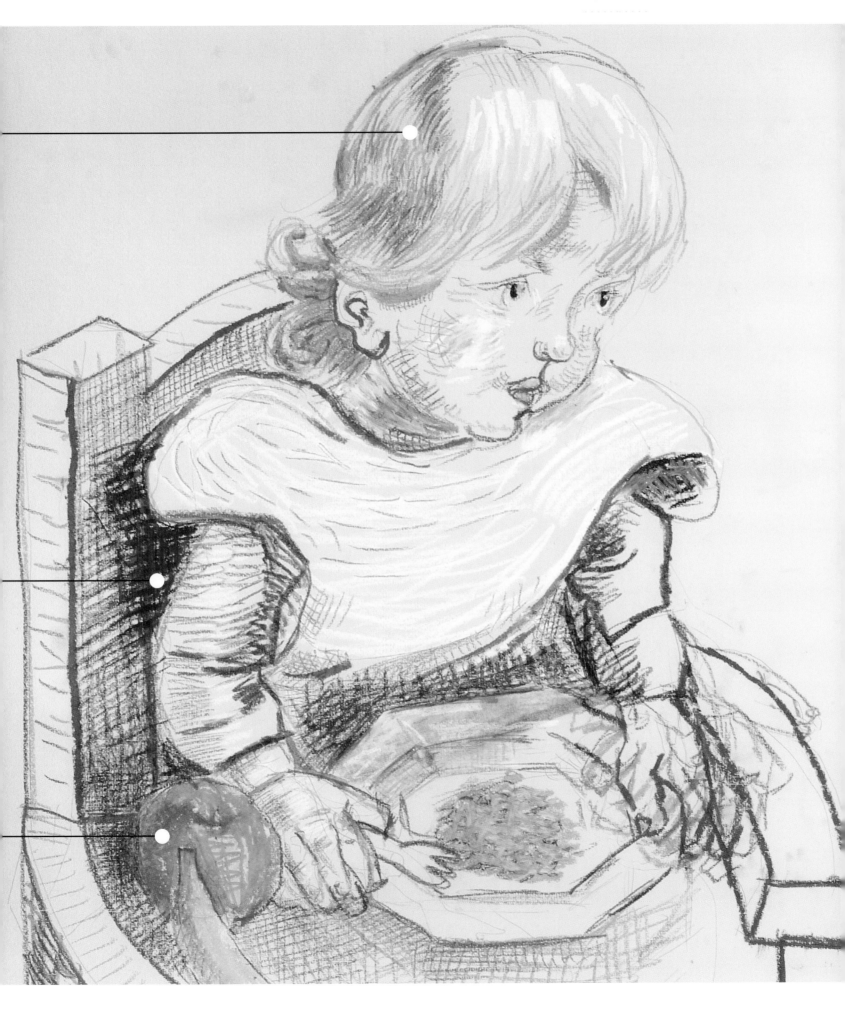

The Process of Painting
with Lines and Hatching

2

Working with hatch lines is based on superimposing lines of different colors. When painting with pastels, you always run the risk that superimposing colors will mean losing the clarity of the tones. In addition, we know that pastels do not adhere as well to applied pigment as they do to clean paper. You can get around this inconvenience by fixing the color with an aerosol after each application. The lines will stay on the paper, and the new applications of color will adhere well to the previous lines and areas of color.

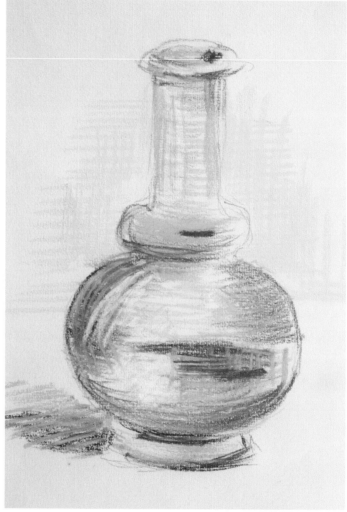

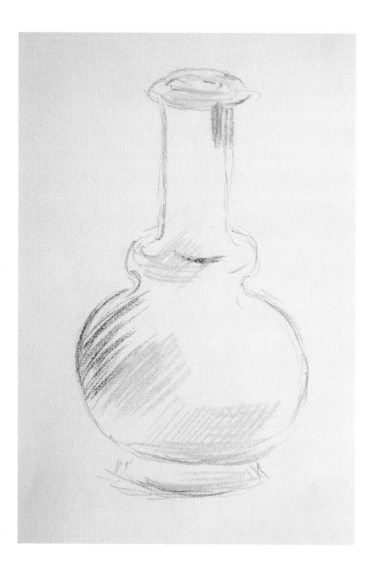

1. The outline of the object is drawn with the same colors that will be used in the painting. The first hatch lines should be light and not very densely spaced so that particular areas do not become too dark and later upset the balance of the piece.

2. Most of the hatch lines are curved, following the form of the surface of the container. This is a basic technique for creating the desired effect of volume. Cross-hatching is applied to some areas, also following the curved shapes of the bottle.

1

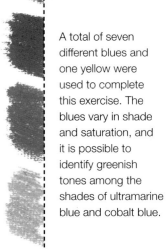

A total of seven different blues and one yellow were used to complete this exercise. The blues vary in shade and saturation, and it is possible to identify greenish tones among the shades of ultramarine blue and cobalt blue.

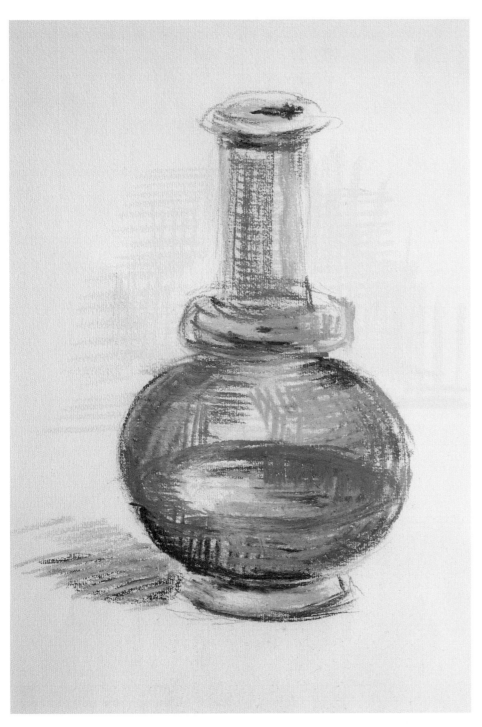

3. The colors used will depend on the area that is being worked. In the darkest areas it will be enough to use one or two colors, whereas in the lightest areas it is best to use a wider range of colors. The yellow hatch lines in the background will create enough contrast for the bottle to stand out with all its volume.

BUILDING UP THE LINES

A pastel painting based on lines and hatching can begin with a simple line drawing made with one or two colors from the selected color range. In the exercise on these pages we use a range of cool colors, mainly blues that go from light cerulean to dark blue green. In the first steps of the work it is best to use the lightest tones and then begin darkening the colors with more intense lines as the work progresses. To create a vibrant effect it is necessary to alternate vertical lines with horizontal and diagonal ones.

Painting with
Areas of Color

Working with areas of color is the most painterly technique available to pastel artists. Its process and the results remind us of a characteristic manner of painting with oils or with acrylics, which has been common since the Impressionists applied their loose and chromatically generous vision to the treatment of traditional painting subjects. This approach basically consists of constructing a form based on colors that are applied to the paper with the side of the pastel stick and allowing the edges of these areas of color to define the outlines of the forms.

In this work the distribution of the colors coincides with the actual coloration of the subject. It is not necessary to interpret the color or to add shading to obtain an exact definition of the shape of the dog, because his coat offers an arrangement of contrasting colors that require only illustration. The applications of the dark colors in the background help to define the outlines of the animal.

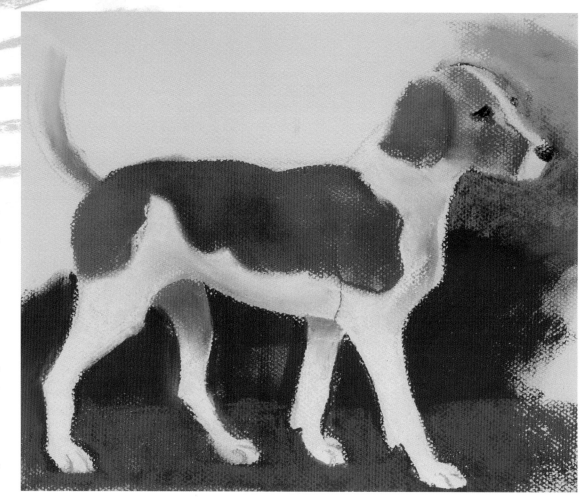

The Impressionist approach consists of finding contrasts between the cool and warm colors throughout the entire work, without reserving some colors for the background and others for the foreground. This results in very attractive and luminous works of art.

CONTRAST AND COLOR HARMONY

The distribution of the areas of color in the work is always based on two things: contrast and harmony. Color contrast creates volume and the outline. Color harmonies enrich, enliven, and add relief to the coloration of the subject. Naturally, the lines and strokes of color play an important part in the definition of the drawing and in the details, but the form is created mainly by the areas of color.

In the examples on these pages you can see different ways of approaching the technique of painting with areas of color. The blocks of color define the form; Impressionistic over-painting or large and saturated applications simultaneously define the drawing and the tonalities.

In these pieces of fruit the volume was not created by chiaroscuro modeling, but by building up areas of color from the same range or from neighboring ranges (reds, earth tones, yellow ochres, and shades of light brown). The contrasting background colors help define the volume of each piece of fruit.

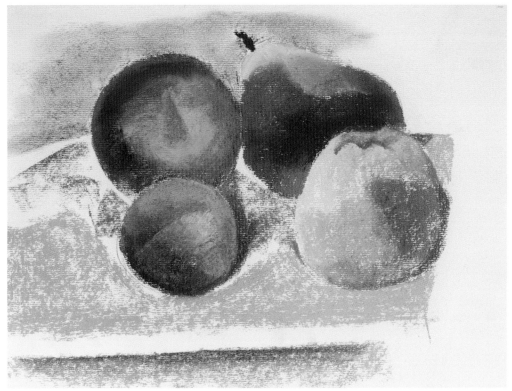

Pastel paintings made with areas of color and contrast have a brightness that is difficult to achieve with lines and hatching. In this work the volume is perfectly expressed by using a few applications of contrasting colors.

Strokes and the Texture of the Paper

It is harder for the pastel to fill the small cavities that form the surface grain of rough-textured papers. Therefore, it is easier to work with successive layers of pigment, and the artistic results can be very interesting. When a layer of color does not completely cover the grain, you can take advantage of curious textural effects to differentiate the surfaces and create contrasts. In these examples you can see different results that combine areas that are partially and completely covered, as well as a work where all the pigment has been blended to eliminate the rough appearance of the support. The rougher the texture of the paper, the more you can play with such effects.

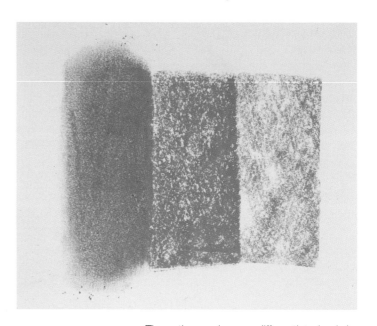

These three colors are differentiated only by their texture. At the left the pigment is blended and all the grain of the paper is covered; next is a dense stroke of color, but it does not completely cover the texture. At the right the color was applied lightly to highlight all the texture of the paper.

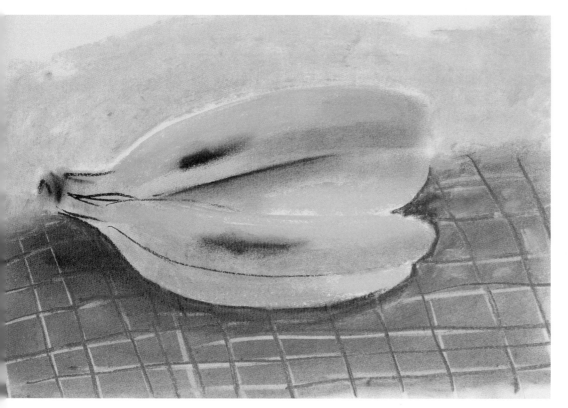

Here all the colors were blended. Notice that the finish is much smoother and flatter than in the other examples. Each subject suggests different approaches, and the artist should be sensitive enough to combine the textures that can be achieved with this medium.

By surrounding the central theme of a work with textured tones (made by very lightly rubbing the pastel stick on the paper), the warmth and saturation of the colors of the subject are highlighted with this very interesting effect of contrast.

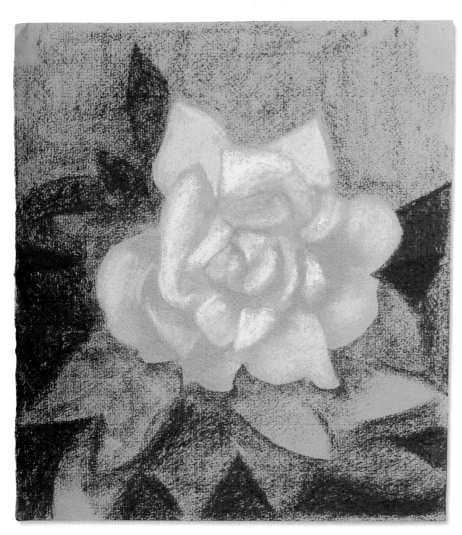

This flower was painted with dense colors that completely cover the grain of the paper. The background and the leaves let the texture show through and suggest rougher surfaces than the evident silkiness of the petals.

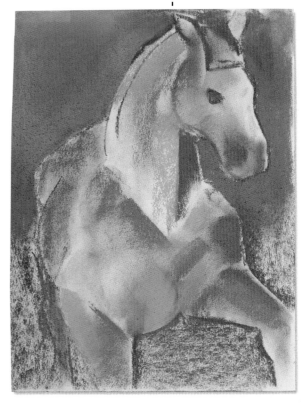

The background of this piece was completely blended, whereas in the body of the horse, blended areas alternate with unblended ones where the texture of the support can be seen. In the lower part the texture can easily be seen in contrast to the rest of the work.

Some experienced pastel artists work without a preliminary sketch, laying out the subject with just a few strokes that express the color and the drawing at the same time (the edges of the color suggest the edges of the form). Work done in this manner possesses a great lightness and demonstrates the artist's ability to synthesize. The artist should give each stroke a specific shape that conforms to the relief and volume of the object or figure being represented.

Light and dark strokes are combined to create edges that define the form and the gesture of the neck. Some white areas have been left to more strongly express the relief of the anatomy at this point.

Strokes of Color
Create the Form

THE STROKES IN A NUDE

The human anatomy is one of the richest and most complex motifs that an artist will see. In the following example all the anatomical factors were resolved by using freely applied strokes and without any preliminary sketches. Painting the back of a figure is obviously much simpler than painting the front. However, in the first case you should pay close attention to the correct placement of the line that indicates the spinal column, because this is the line that determines the movement of the figure. This line, like the rest of the lines that appear in the work, is created by the contrast between the strokes and not by a direct line.

The hollow of the spinal column is defined by a single stroke of darker color that follows the back and contrasts with the previously applied colors. The effect is definite and clear, with no need of any elaborate chiaroscuro.

Pastel colors can be retouched with white to make a lighter tone. However, overuse of white will cause negative results, graying the colors and giving them a matte appearance. It is better to use the widest possible range of light colors.

As in the previous case, the volumes of the gluteus are created using simple semicircular strokes that contrast in chiaroscuro with the rest of the applied colors.

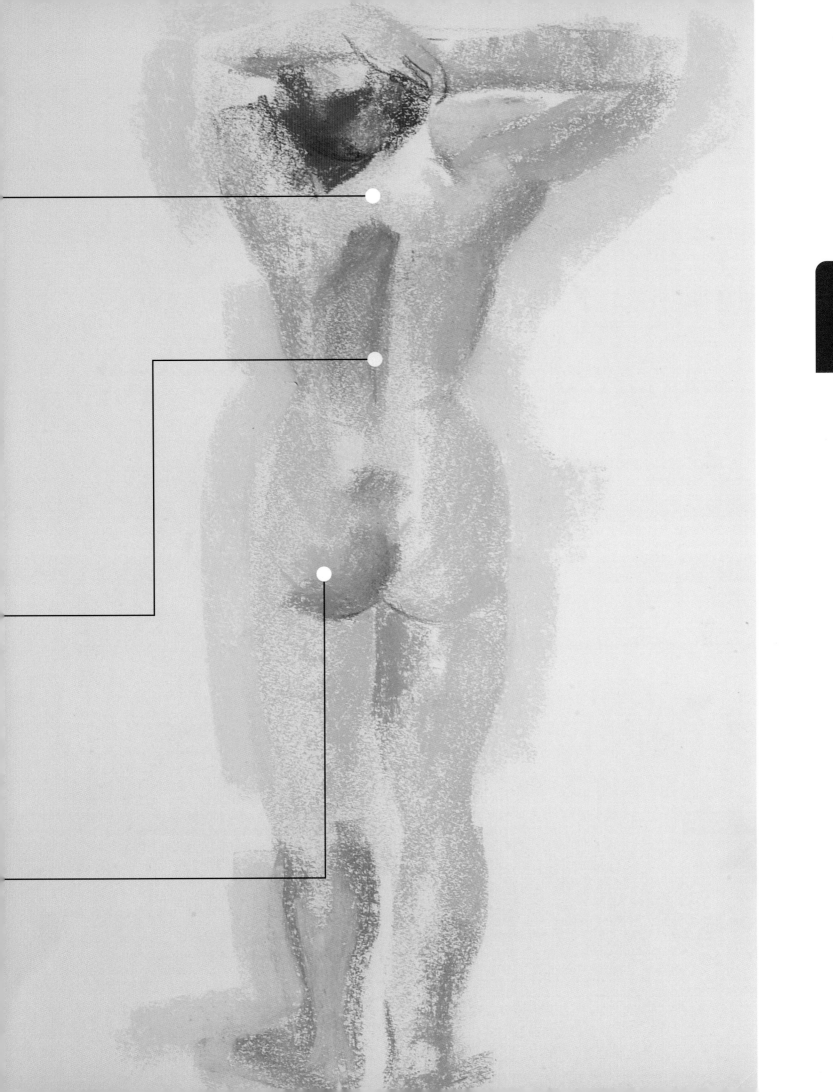

Resolving a Form with Color Strokes

On the following pages we will show the process for working with color strokes that was mentioned before. This is a very simple exercise: a piece of fruit that is resolved with only a few strokes of color that are neither blended nor reworked. The result is richly colored and very painterly. After analyzing this process, you will see that direct painting without a preliminary sketch is the richest and most colorful of all the pastel techniques.

PAINTING AND CORRECTING

Pastels allow corrections as you go along, as long as they are made in the first phases of the work. These corrections can be made to the drawing or the color. In any case, it is a good idea to always refine the outlines as you work and to create the volume with applications of color. It is best for the outlines to be very generic at the beginning and to refine them more and more during the working process.

1

2

1. Instead of drawing lines, you can indicate the fruit using a curved stroke of red to define the form and its size. The stroke should be made lightly so you do not saturate the paper from the beginning. This way the successive colors can easily be applied over the original stroke.

2. In the area with the least amount of light, which will correspond to the shadow, red was applied heavily, using more pressure on the paper with the stick. In addition to this, light yellow strokes were added to approximate the form and the color of the internal volumes of the piece of fruit.

3

3. Within the yellow part you can see traces of green. These are light strokes that were applied before the yellow and then blended with it by applying pressure while drawing with the pastel stick. After these colors, we returned to using red, which was applied over the yellow area to create shades of orange.

4. The small cavity at the top was indicated with charcoal. This creates a relief effect that helps define the volume of the fruit. Finally, the blue strokes suggest a shadow in the background, and they intensify the color of the fruit through simple chromatic contrast.

Notice that the colors used in this exercise are full and saturated. This promotes rich results despite the simplicity of the subject, and they add a beautiful luminosity to the finish.

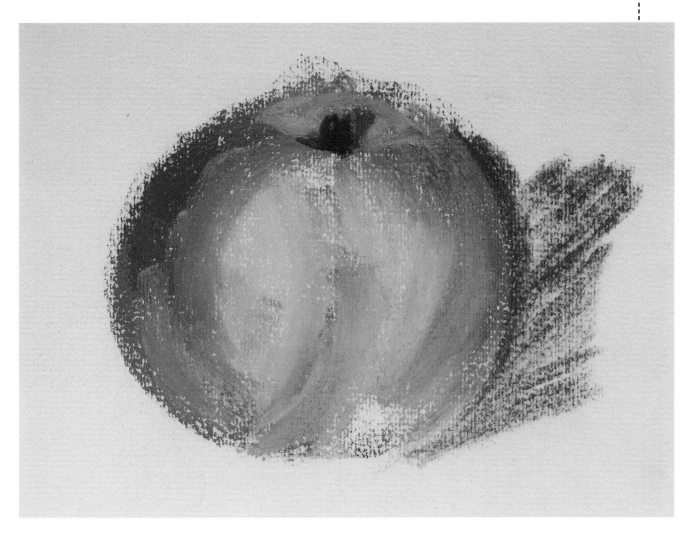

4

Mixing and Combining

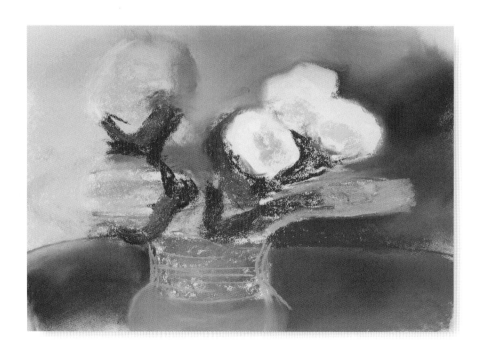

DAVID SANMIGUEL.
FLOWERS, 2006. PASTEL ON PAPER

Colors

The very wide range of colors available

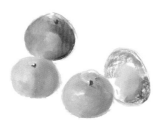

to the pastel artist reduces the amount of mixing that must be done. Ideally, the artist should keep mixing to a minimum and always use direct colors for their freshness, cleanliness, and saturation. But often it is necessary to rub two or more colors over the paper to make just the right tone. In this chapter we will talk about these techniques and about how to combine colors to achieve the brightest and most painterly effects by alternating highly saturated tones with those of little saturation.

Blending is a typical pastel painting technique. It consists of using the fingers, a blending stick, or cotton to rub the colors over a previously colored surface. If you rub briskly, the colors will completely blend and create a perfect transition from one to the other. This technique resolves the problems of mixing and transitions between light and dark colors, and renders very good results in works that consist of an isolated and clearly defined subject. However, it is not a good idea to take it too far in elaborate works of art, because it reduces the luminosity and kills the necessary vibration and freshness of the tones.

Mixing Colors by Blending

LINES ON BLENDED BASES

Blending not only spreads and mixes the colors, but also completely covers the grain of the paper by saturating it with pigment. It is very difficult to apply new lines or color over paper that has been covered like this. The pigment will not adhere to the base of color, and all it will do is make it muddy. The solution is to fix the blended areas. After they have been fixed with a light coat of aerosol, the surface colors will accept new applications because the pastel pigment will adhere well.

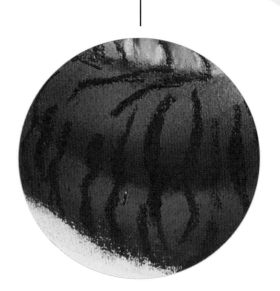

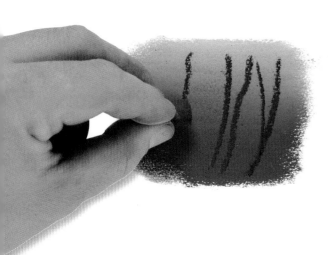

After fixing the blended colors, it was very easy to delineate the stripes on the tiger by drawing with a stick of dark pastel color.

The base color of the tiger's body was created by blending yellow and red (red oxide) strokes until the characteristic chestnut color of the tiger's pelt was achieved. Over this blended and fixed base color the stripes were drawn with a dark earth tone.

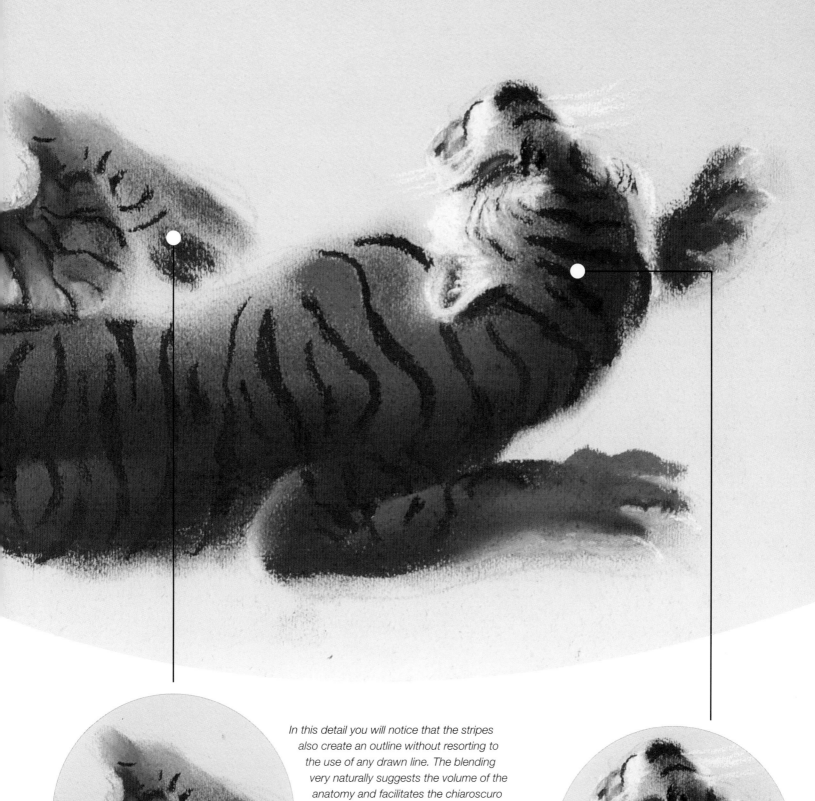

In this detail you will notice that the stripes also create an outline without resorting to the use of any drawn line. The blending very naturally suggests the volume of the anatomy and facilitates the chiaroscuro that gives form to the tiger's extremities.

The details and the difficulties of the drawing accumulate in the head, but they are resolved with pastel pencils. Here you can see how the use of a lightly colored support allowed us to highlight the white of the tiger's fur.

The Blending Process

The development of a pastel painting based on blended colors always begins as a work of color strokes, but those strokes must be especially large to facilitate blending them with each other. Blending is always done during the first steps of the painting, and all the details, shading, and highlights should be left for the end, especially if fixative is used to set the intermediate layers of color. In the following example the first strokes are blended briskly without worrying about the edges, spreading the color as much as possible. Then, new colors are added and the piece is shaded.

BLENDING IN LANDSCAPES

Blending is an ideal technique for atmospheric effects in landscape because the tones lose their saturation, blurring and blending with one another. But even in landscapes where the atmosphere is not relevant, as in the next sketch, blending has the function of generalizing the details to create masses of color upon which the most important highlights stand out. Then the blending allows you to suggest missing details and create a generic and universal vision of the subject.

1

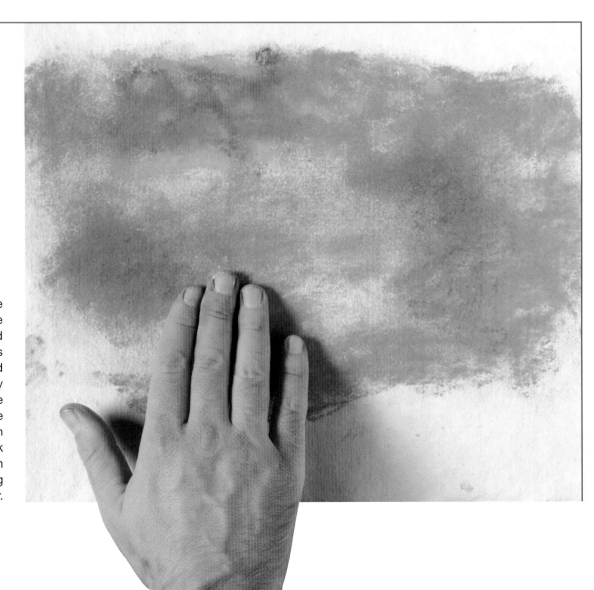

1. Beginning in the foreground large areas of green and some yellow notes are laid down and then blended briskly with the fingers. The blended areas are separated from each other so they will look like irregular terrain instead of becoming a block of solid color.

Blending helps you construct the work using large blocks of color. Spreading the pastel color with the fingers saturates an entire area of the paper with a uniform tone. In this work the composition is based on the contrast between these areas of homogenous color.

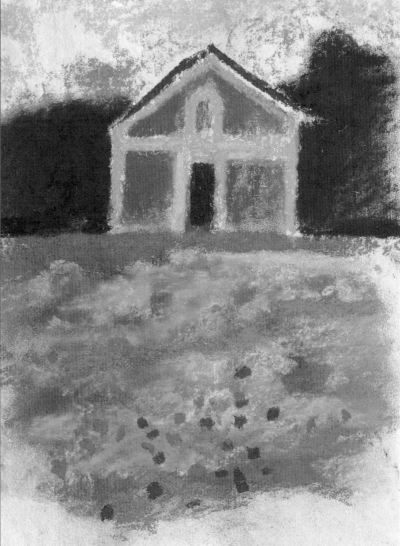

2. In the upper part of the composition are some colors that create a synthesis of the house and the woods that appear behind it. In the field we continued to blend the color and added yellows on the green to shade it.

3. More shades of yellow were added after fixing the color of the field, and touches of red pastel were added to represent poppies. Using fixative became necessary, because without it the added red colors would not have adhered well to the base color.

The Use of the Color White

One of the reasons large ranges of pastel colors exist is so the artist can avoid using white to create light colors. A look at the most complete boxes of pastels will show you the enormous number of shades that exist between two neighboring colors. Some of the shades are so subtle that it is not easy to discern the difference between some colors. The ideal would be for you to have the right stick at hand for each tone, and to use the color white only for the pure whites. This is not always possible, and it is not uncommon to have to lighten some colors by mixing them with white, as you will see in the exercise on these pages.

1

2

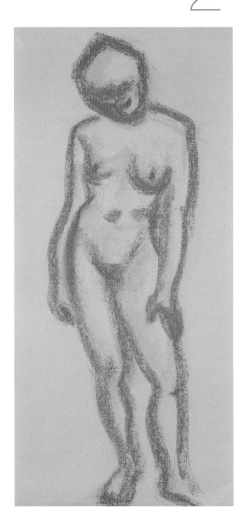

1. The figure is blocked in with wide strokes of pink to create an anatomical figure without going into details. This light tone will later be integrated with the rest of the colors by blending.

2. After the figure has been defined in its correct proportions, it is outlined with a darker color such as burnt sienna to indicate the definitive shape.

MIXING WHITE WITH FLESH TONES

In this exercise, white is used to unify the shades of color of the skin that were applied in the first phase of the drawing. The white is blended with the previous tones to give the figure unity. A pastel painting, especially one of a figure where all the colors are completely blended, can end up being monotonous. You must be careful about systematically blending all the surfaces, because they can become bland and lose their definition. You should always combine blending with direct line work or unblended areas of color.

4

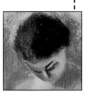

In a nude it is not a good idea to add too much detail to the face. This should be left for portrait work, where the expression is most important. Here you are not after the personality or the psychology of the model, only the beauty of the forms. Therefore, treat the face as just another form, with few details.

3

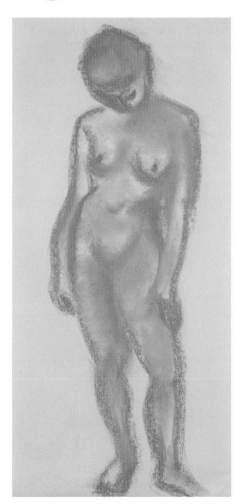

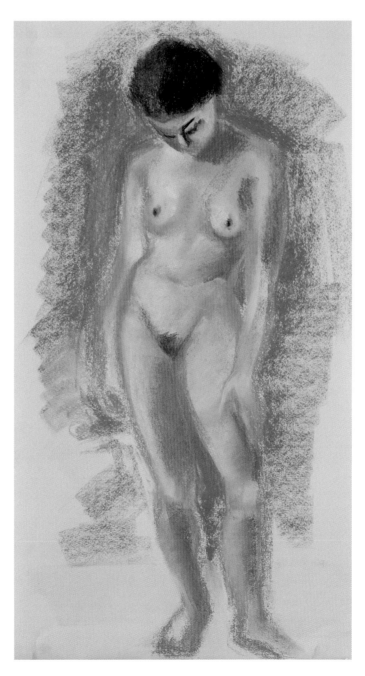

3. The entire figure is colored with pinks and light browns. In this phase the colors are very dark, but later they will be lightened with white.

4. To finish, white pastel is added to all the illuminated areas, and then it is blended with the original colors. The warm ochres, yellows, and pinks are not enough to represent the pearly quality of the skin. It is necessary to introduce contrasting cool colors to highlight the flesh tones. Used prudently, blue is an appropriate color for this.

Blending and the Volume of Forms

Pastels can represent volume using lines, colors, and blends. The last of these, however, is the one that creates the most realistic results. Blended surfaces are continuous; they do not show breaks from one color to another or from one line to another. Blending creates a single progression of colors that move from the lightest light to the darkest dark in a way that we usually observe in reality.

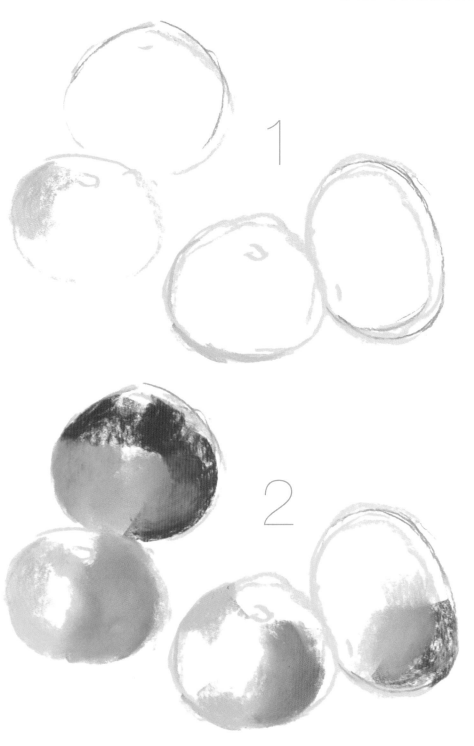

1. First, the outline of each piece of fruit is drawn with the lightest color from its range. Here it is yellow. Some simple curved lines are enough to locate each fruit in the correct position with respect to the rest.

2. The interiors of the fruit are colored with greens and yellows, leaving them white at the points where the light is at its brightest. The colors meet at their edges, and this is where they should be blended.

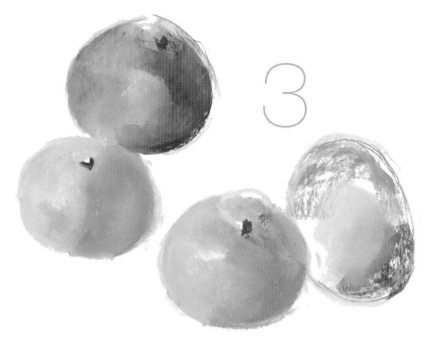

FROM A COLOR PLANE TO A COLOR SPHERE

Here we approach the problem of converting the different planes of color on the fruit into spherical surfaces that contain those planes without breaks or discontinuities. The solution, obviously, is blending. But this must be a careful blending that does not mix the different colors too much, which would damage the beauty and richness of the finish. Blending should be done only where the colors come into contact with each other, respecting the areas where the colors are most saturated or lightest. In other words, blend only the intermediate parts between the light and shadows.

3. The blending was done very carefully. After each application the fingers were cleaned to avoid contaminating colors accidentally. The lightest areas were left alone, as were the darkest parts.

4. Finally, a few strokes of contrasting blue are added to suggest a plane or surface where the fruit sits.

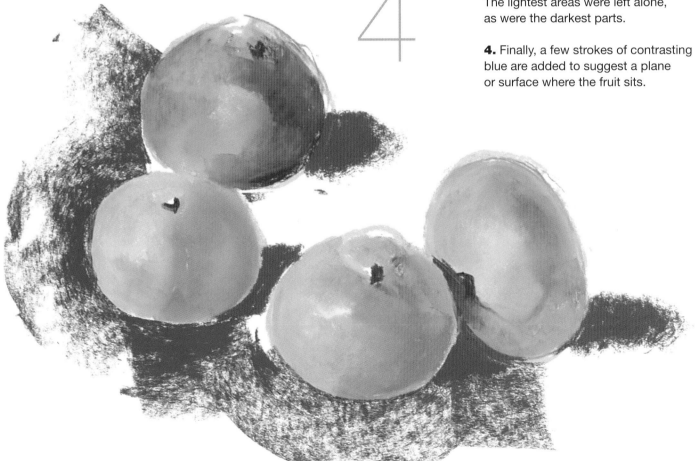

Draw-ing

and Painting Techniques

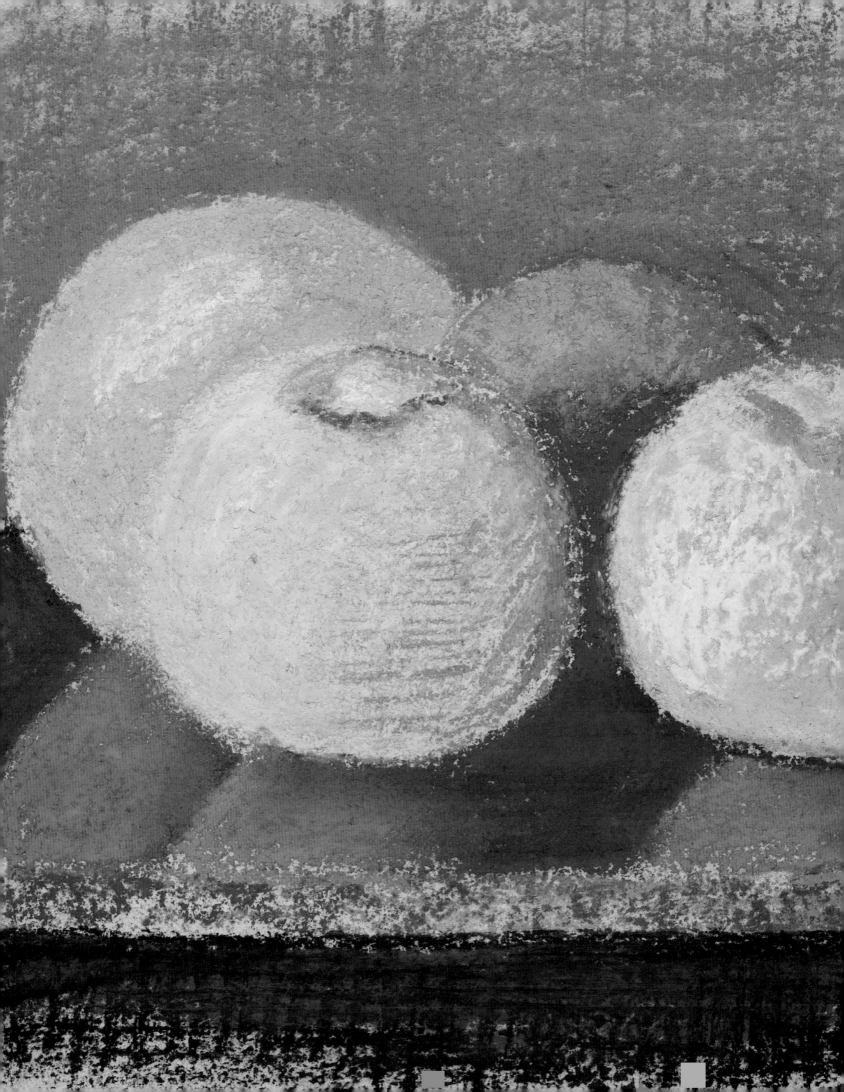

Values:
Between Drawing

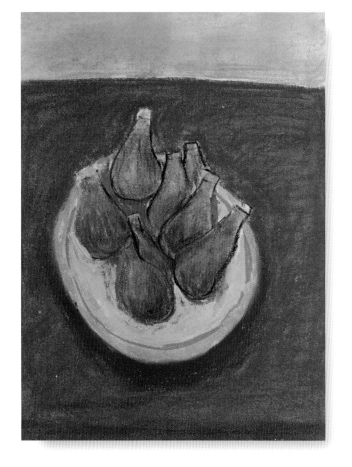

and Color.

In pastel painting

drawing and color can

blend with each other to the point that it is not possible to distinguish where one ends and the other begins. The colored lines draw and paint the subject simultaneously. The lines are also fragments of color that combine completely with areas of color. This is one of the great qualities of pastel painting: It allows you to paint and draw at the same time. Pastel sticks are a drawing medium and a painting medium at the same time. This weaving together of two art forms is exactly what lets us create value in a subject, the way we can adjust the light and dark tones until we arrive at a satisfactory result.

Drawing with Color
and Coloring the Form

You know that a very precise preliminary drawing is not required for developing a pastel painting. Almost all issues can be resolved using color, and it is not necessary to resort to drawing to complete the work. Not only is it not necessary, but it can sometimes be a hindrance when applying color. When artists paint, they should feel free to interpret the form using color. Sometimes that interpretation can contradict a drawing, or modify it, or show a new version of the subject that was not seen in the original sketch. For these reasons it is as interesting to "undraw" as it is to draw as you go. The line should not be tyrannical, and it has to allow other possibilities, and not completely enclose the form.

A GUESSING GAME PROCESS

In this work you see how the forms in the theme alternate drawn details with aspects that are resolved solely with color. It is very difficult to precisely identify the exact border between line and area of color. This is typical in pastel painting, where the artist defines outlines with shades of color and creates surfaces using lines. This plate with fruit presents several solutions to the problem, from a precise outline of the shape with a monochrome line to the accumulation of colorful hatch lines that shade previous areas of color, to create a final picture of the form of a piece of fruit.

The presence of a piece of fruit in the mid-ground is simply suggested with two strokes of contrasting colors. The blue stroke expresses the projected shadow of the upper piece, and the yellow stroke evokes the color of the partially hidden fruit.

Each subject can suggest a different approach to the artist. Some aspects of the theme can be resolved with solid blocks of color and others with lines, as in this example, where the sky is represented with dense areas of color and the dunes on the beach are defined with multicolor lines.

The word gradation always suggests blending or a work that is essentially painterly, although here it is done using red lines, livened up with some yellow color, that follow the curved shape of the fruit and describe its volume.

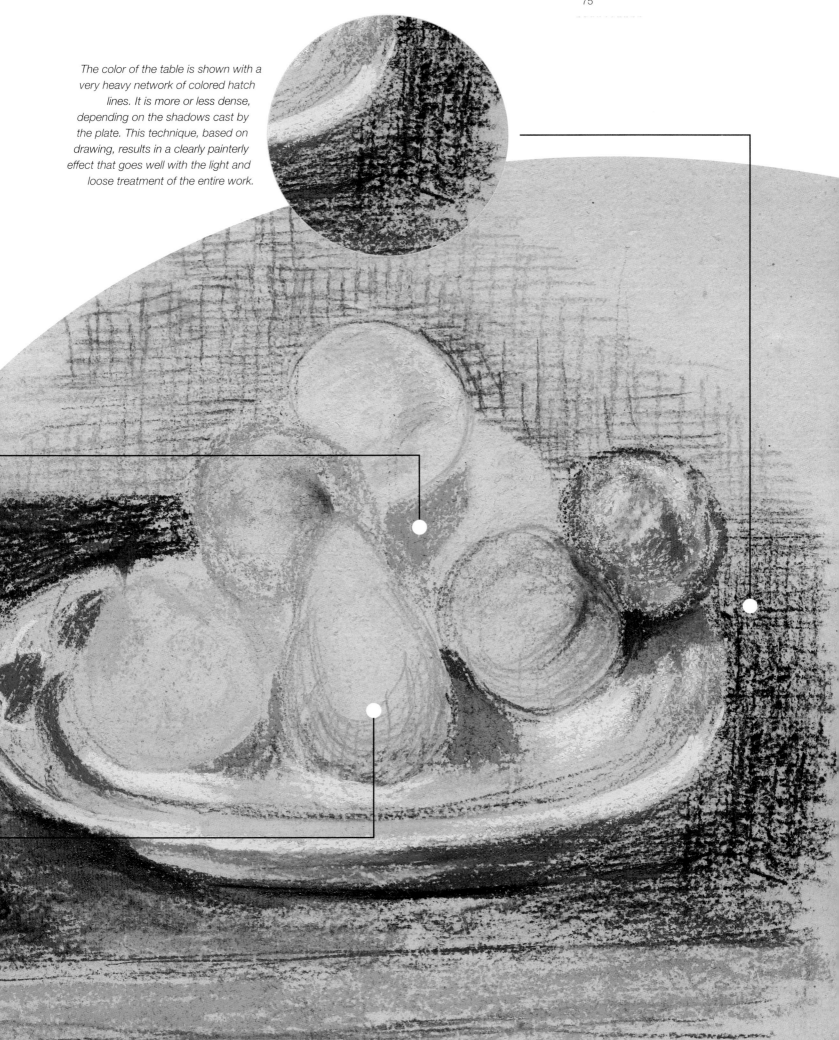

The color of the table is shown with a very heavy network of colored hatch lines. It is more or less dense, depending on the shadows cast by the plate. This technique, based on drawing, results in a clearly painterly effect that goes well with the light and loose treatment of the entire work.

A Drawing as a Suggestion of Color

A preliminary drawing can be a great help for a later painting if it suggests the forms instead of illustrating them completely. Suggesting form means responding quickly and spontaneously to a vision of the theme and drawing the instant of that vision on the paper. This affects not only the outlines, but also the general shading of the subject, because all initial drawings must respond not only to the outlines of the forms in the theme, but to the relationship between the light and dark values that compose the scene. It does not matter if this initial concept is done with one or several colors, but the preliminary sketch with lines and colors must have a unified feeling and a sense of harmony.

This value study was done in charcoal. The gray areas suggest colors, and the lines mark important accents that should be kept in mind in the final painting, being converted into contrasting colors

This sketch of the scene was made with charcoal. It is a first step for a more elaborate work based on the above study. The treatment of the values is much more restrained, and the only areas that are shaded with black are those that in the end will have the darkest colors of the composition.

This sketch is a color study for a still life. As a preliminary sketch it is a bit risky because it obliges the artist to continue to work with a few very saturated colors. But because this is a simple composition, it is an acceptable and appropriate approach.

DRAWING AND VALUE STUDIES

A monochrome drawing can be done in any color, and it will determine the general tones. The more intense the value study, the more intense the colors required to follow those values. If the artist is unsure about what the general tone of the scene will be, he should make some small studies before confronting the final work of art. These studies should be done with a dark general tone that can easily be charcoal. When you work with strong values, it is easier to see the overall effect that will later be applied to the pastel painting.

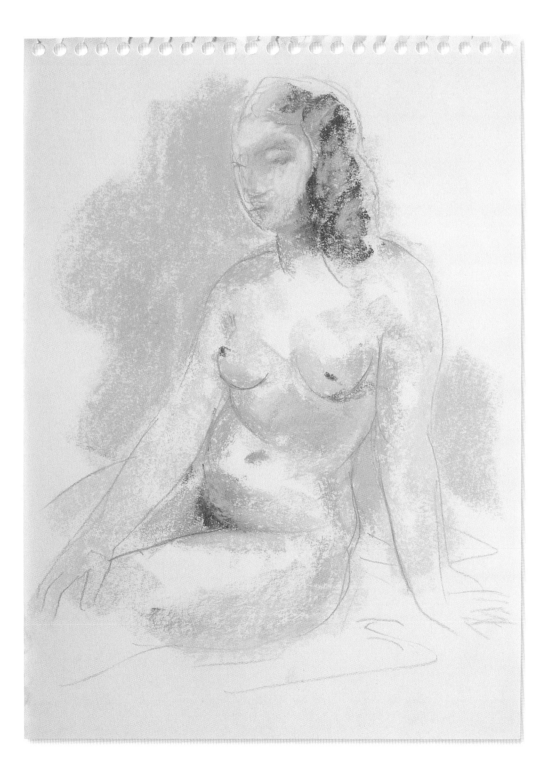

Here the drawing, the color, and the values all work together. This is a simply sketched work that did not require a detailed value study, because the space that surrounds the figure has no relevance.

The Chromatic Values in a Drawing

In this work you will see that the chromatic value of a drawing is made with just a few tones that define the coloring and volume of the subject—that is, the general tone and the chiaroscuro. We have chosen as the subject a figure that is a conventional line drawing (a light line) that is then shaded with colors that basically reinforce the previously drawn lines of the anatomy.

SIMULTANEOUS CONTRAST

This approach consists of indicating the profiles of the subject with contrasting colors without covering the lines with the color. By surrounding the outside of a light area with a dark color we create the outline without having to draw it; the same can be done by covering the outside with a lighter color. This way the drawing and color form a single inseparable entity because the lines are created by the colors. This is especially useful for creating continuous colors that are not interrupted by unnecessary lines or strokes.

1

1. In this exercise the drawing task and the coloring task were separated. The figure was drawn in a linear style, clean and monochromatic. This way the chromatic values will not be affected by any ambiguity in the anatomical form.

2. The internal volumes of the figure are indicated with strokes of warm color that follow the lines of the drawing. The contrast between the darkness of the color and the white of the paper suggest the distribution and order of the anatomical relief.

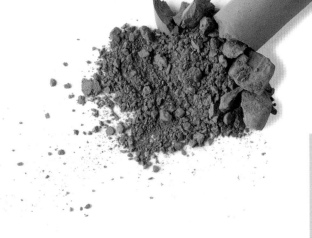

TRANSITIONS

The use of simultaneous contrast as a technique for defining the shape of the figure without using lines is very interesting as long as it is not systematic. If you enclose the figure on all sides, it will look like a cutout against the background and the effect will seem suffocating and artificial. It is very important for the contrasts to leave space for blending some parts of the figure into the background and for the color of the figure to be confused with the background at some points. This will cause the figure and background to integrate, to become one so that the background can be recognized as a space occupied by the figure and not a plane that is independent of it.

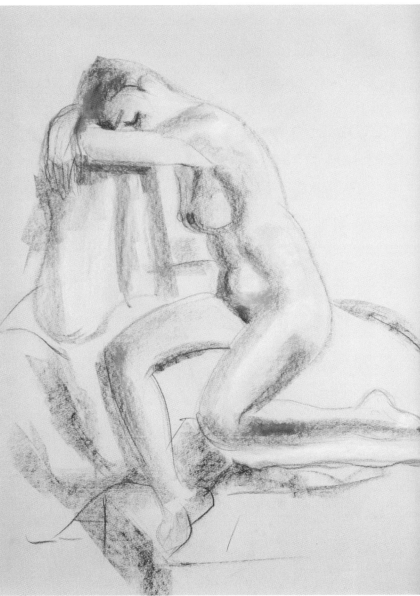

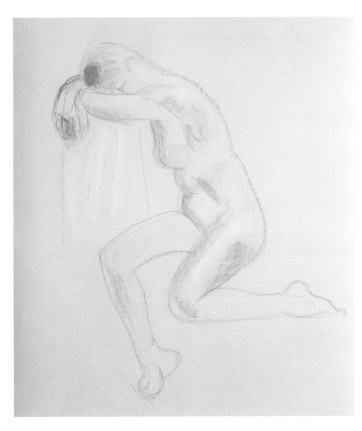

3. The strokes of light ochre establish the intermediate tone of the value (the tone that is between the lightest light and darkest dark in the figure). Then the shapes of the most shaded parts stand out because of the simultaneous contrast between the dark colors and the white of the paper.

4. The folds in the fabric are indicated with wide strokes of cool color. The color, shape, and distribution of the strokes contrast with the colors of the figure. In the lightest areas of the back the drawing does not completely enclose the volume, and it suggests a generic space or environment in which the figure is located.

Values Created by Contrasting Strokes of Color

All colorist painters make use of contrasting areas of color to create space in their work. If you do not use chiaroscuro, which creates space by using tonal gradations, you have to express depth in the representation by making colors contrast with each other. Generally, this is done by contrasting light colors against intense colors, finding combinations of complementary colors (which intensify each other) distributed between the figure and the background. The viewer's eye will interpret the contrast as a spatial distance, like a relationship between foreground and background.

1

1. In this work we do not require any preliminary drawing to directly address the color values. The first phase is limited to creating the essential contrast between warm and cool areas, using lines that are an initial, yet very preliminary, approximation of the form.

2

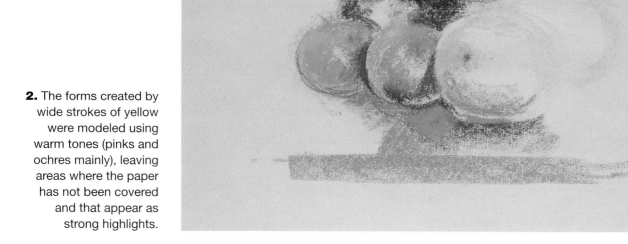

2. The forms created by wide strokes of yellow were modeled using warm tones (pinks and ochres mainly), leaving areas where the paper has not been covered and that appear as strong highlights.

THE STRENGTH OF THE CONTRASTS

These values require strong contrasts to work well; otherwise the structure of the subject will get lost among the common and typical shading of the color. For example, a very dark shape against a light background will advance toward the foreground, as will a very light form against a very dark background. This is because the nearest forms have greater contrasts; they have darker parts and lighter parts than the rest of the composition.

THE PROCESS OF CREATING VALUES WITH COLORS

This exercise is inspired by the work of Cézanne and is an attempt at a pastel version of one of his magnificent watercolors. Cézanne was a master at using chromatic values. In his works the shapes of the forms are the simple consequences of color valuation. The process shown here makes no use of linear drawing, constructing the volumes with only contrasting colors.

The contrast between large light and dark areas can be enough to evoke the distance between the foreground and the background. In this sketch, the plane that the cat rests on moves toward the foreground because it contrasts with the dark background.

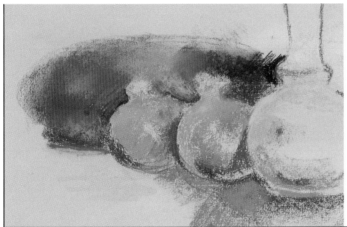

3. The onions stand out strongly in the painting because their warm and light colors are surrounded by cool tones, which are much darker in the area of the middle ground. This double contrast of color and value (light on dark) causes the shapes to advance to the foreground.

4. Finally, all the objects in the still life have been clearly defined, thanks to the many contrasts between colors. The general shapes and the volumes of the elements stand out quite a bit because of the contrasts.

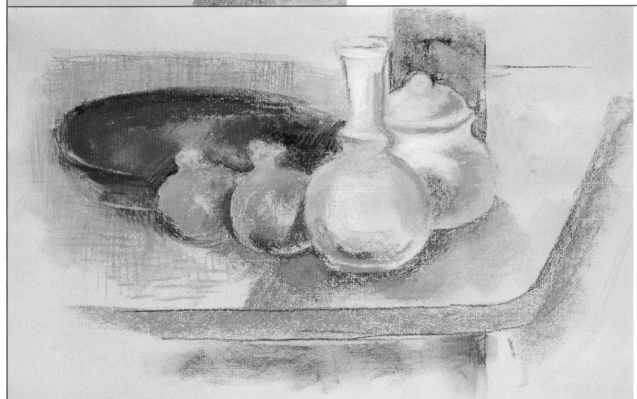

The atmosphere or continuity of all the parts in a single coherent space should exist in all paintings from almost the beginning of the work and should be a product of the values in the color. This is the opposite of the hard outlines and the exaggerated exactitude of a drawing. The atmosphere should be fluid, continuous, without interruption, united. Although this may seem very difficult to represent, in reality, when harmony has been achieved in the painting (balance, rich in contrasts, with unity), its atmosphere is already suggested and will come into being on its own.

Blending was used in all the areas of color in the composition, and details and lines that define the shapes of the houses and palms were added over the blending.

Values and Atmosphere in the Work

THE LUMINOSITY OF PASTELS

The intensity and quality of a color harmony will determine the luminosity of a work of art: the tonalities of the colors, chiaroscuro (or lack of it), the contrasts, the greater or lesser use of modeling, the use of flat colors, or richly shaded colors. In this landscape we have illustrated all the bright, radiant light of midday at the seashore. This was achieved by the simple use of values in the different areas of color, the beach in the foreground, the strip of buildings, and the sky. The contrasts are clean and do not have much intermediate shading between one area and the other. The overall light intonation is highlighted by the dark accents of the palm trees and the vegetation of the promenade of this coastal town.

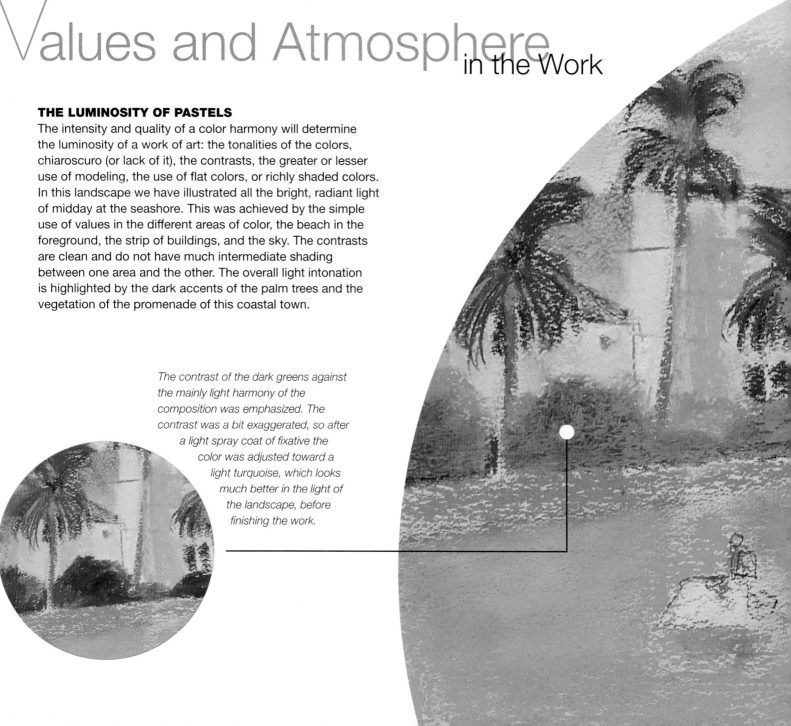

The contrast of the dark greens against the mainly light harmony of the composition was emphasized. The contrast was a bit exaggerated, so after a light spray coat of fixative the color was adjusted toward a light turquoise, which looks much better in the light of the landscape, before finishing the work.

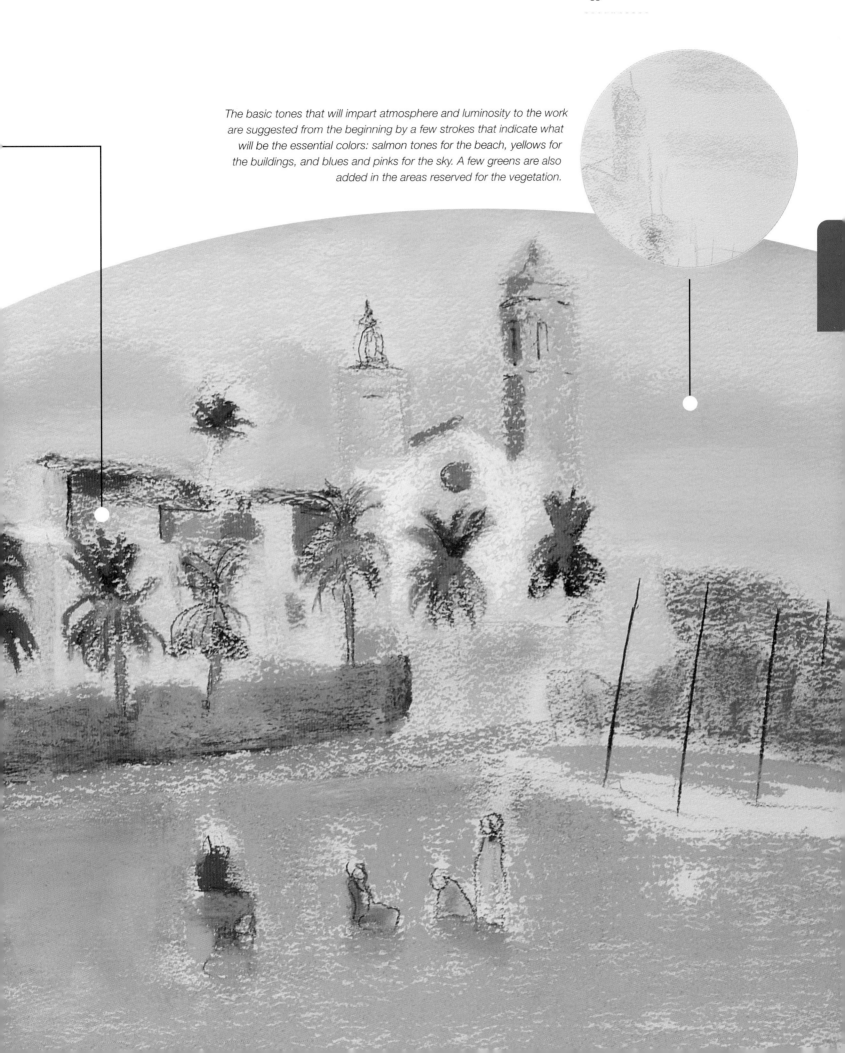

The basic tones that will impart atmosphere and luminosity to the work are suggested from the beginning by a few strokes that indicate what will be the essential colors: salmon tones for the beach, yellows for the buildings, and blues and pinks for the sky. A few greens are also added in the areas reserved for the vegetation.

Value, Modeling, and the Color of the Support

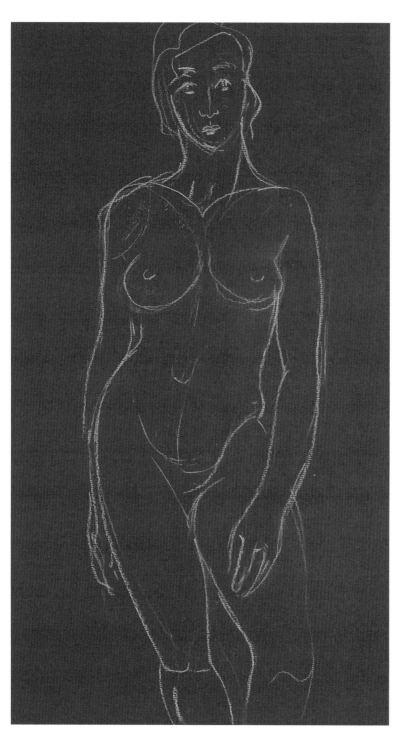

Modeling is a very popular technique among artists who wish to show the sculptural aspects of the figure, of the almost tactile sensation that the forms are rounded and occupy a deep space. This is achieved by a direct use of value in the light and shadows of the body of the model. The intense modeling of the figure represented in this exercise reminds us of a sculpture. The more intense the chiaroscuro, the more contrast there is between the light values and the dark ones, the greater the sense of volume you will be able to create, and the more evident the effect of light on the form. The volumes are approached in synthesis, and wherever the transition is brusquely interrupted, the effect will be that of an edge or outline.

DARK COLOR PAPER

The color of the paper not only favors and encourages the harmony of the pastels, but also is a very efficient medium that helps create values in the painting. If it is a dark color, it participates in the modeling of the subject. This piece was done on a chocolate brown paper, on which the light colors stand out strongly. It is not usual to work on such dark supports, but on this occasion the choice is justified by the results, where the volume of the subject is emphasized and strongly evokes the sculptural form.

1

1. Drawing on dark paper with white pastel is like drawing in negative, but the intensity of the line stands out almost as much as a charcoal drawing on white paper. For this modeling exercise it is best to make a clean and well-defined line drawing.

2

3

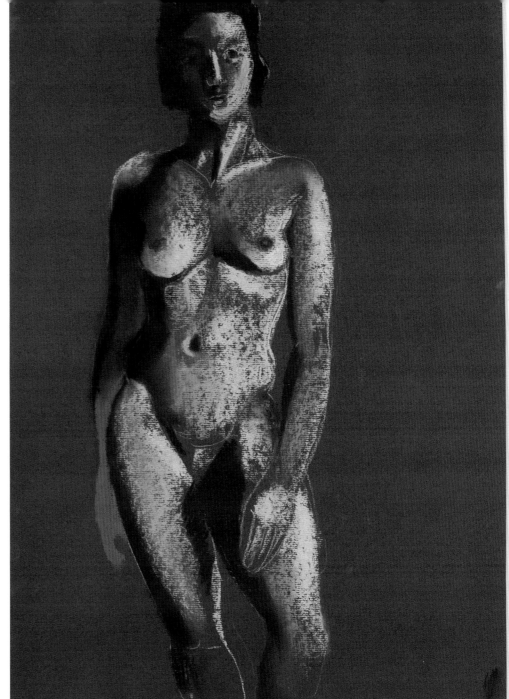

4

2. All the surfaces of the figure that receive direct light are colored with a very pale yellow or the same white stick of pastel applied flat on the paper.

3. A warm color was chosen to create the necessary transitions of the shadows, from the same range as the background color, to naturally connect the lightest tones with the darkest. The color in this case is ochre, and it is used to cover those areas of intermediate light.

4. Finally, the darkest shadows are reinforced with black. This way the darkest outlines of the figure will be well defined. Notice that we did not blend the colors with each other, because this would blur the figure and ruin the strong sculptural effect.

Chromatic Harmony

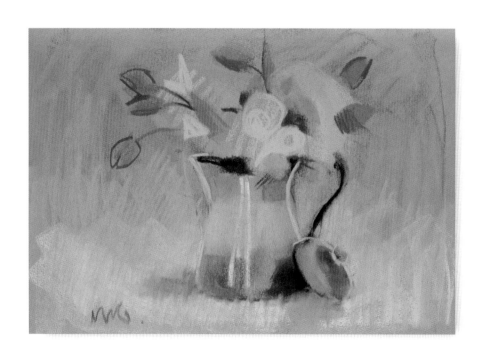

with Pastels.

We know through intuition that colors

relate to each other in a way that some of them harmonize better than others, much like a "family reunion" of tones that maintain a good relationship. Yellow, for example, mixes well with certain greens and with the oranges. Red relates comfortably with carmines and pinks, and the earth tones and browns also make up a family with chromatic harmony. We could continue reuniting families, because it is always a stimulating exercise and fun to do by coloring on paper. But all the possible varieties can be summed up in three big families of color: the warm colors, the cool colors, and the broken colors. These classifications relate to psychological responses that are difficult to demonstrate scientifically but are quite evident when we have examples at hand.

Color Harmony in the Warm Ranges

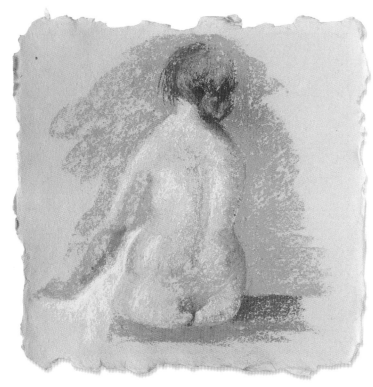

The warm colors are those that range from yellow to orange to red. Psychologically, we relate them to light, blood, human flesh, sand, and so on. The colors do not in themselves have a specific "temperature," but it can be perceived in relation to the tones that surround them. A warm green can seem cool when surrounded by warmer colors, but next to cool tones its "temperature" increases. This is why it is important to incorporate certain cool tones in a large group of warm colors: the cool color will make them stand out.

Cool colors are commonly used to bring life to the harmony, even when you are deliberately working with a single tonal range. In this example the blue creates an important contrast to the rest of the yellow and red tones.

The figure is the subject that most clearly requires rendering in a warm color range. Flesh tones, the colors of the human skin, are essentially warm, although they can show cool shades caused by reflections of other surfaces with cool tones that are near the model.

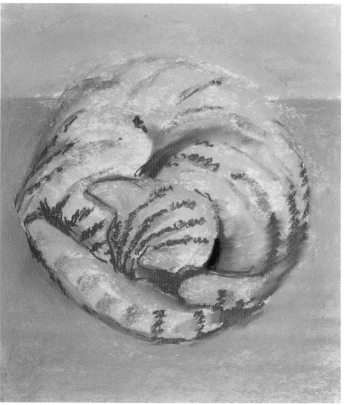

These are the warm colors used to paint this still life. Working exclusively within a range does not mean limiting the color, only creating a unity among all the tones.

A COLOR SCALE

Organized intuitively and according to their level of saturation, warm colors run from carmine reds and deep earth tones to light raw sienna and the yellows at the other end. Between these two extremes a great number of different tones are offered by manufacturers.

Some boxes with large selections have ranges based on subjects, such as figure painting. They have warm ranges that can also be used for many other subjects, as you can see on these pages. Here we show the range of warm colors that were used to paint this still life.

This still life was painted using the wide range of warm colors that are illustrated at the side of this page.

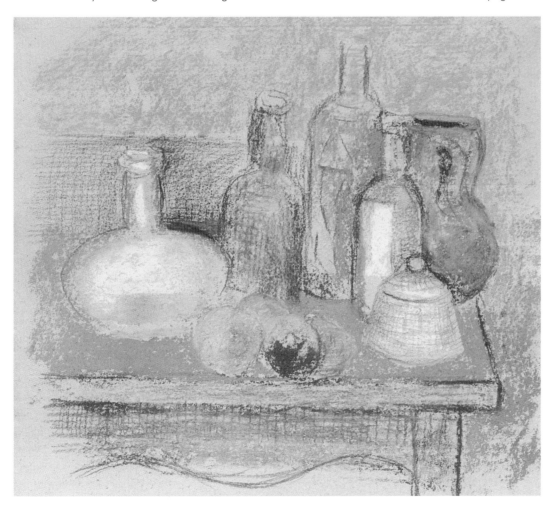

Laying Out a Work with Warm and Cool Colors

Contrasting colors create a sense of space by themselves. More precisely, the contrast between two colors suggests a distance between both of them. One of them always seems closer, and the other farther away. This suggestion of distance is accentuated when we pair a warm color with a cool color: The warm advances and the cool recedes. All painters know this fact and use it in their work. The effect can be seen very clearly in landscapes. The contrast between warm and cool colors is seen first in the sky (cool colors) and the ground (more or less warm colors). This exercise makes use of contrast in the most intense manner, contrasting all the colors as much as possible.

1

1. The colors in the background are cool but very bright colors: turquoise blue for the sky, mauve-violet for the mountain, and saturated greens for the treetops. The contrast of the yellows that will occupy the center and foreground of the composition is lightly indicated.

OPPOSITIONS BETWEEN THE CHROMATIC RANGES

If you wish to place a form in the near foreground, you can paint it with an intense warm color—yellow orange, for example—and contrast it with cool colors around it. These colors will recede visually toward the background. This is a way to create space without using perspective. Keeping the factor of distances in mind, Miquel Villá painted this landscape, striving for the greatest contrasts between warm and cool colors. The result is a painting of space that is completely based on color.

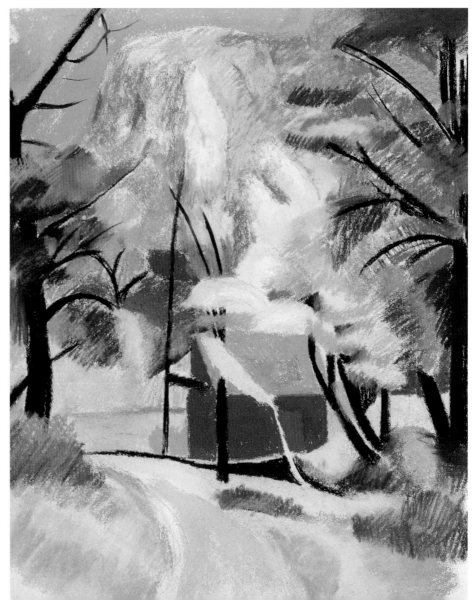

2. The central red (of the house) adds a strong chromatic emphasis that highlights the yellows around it. Meanwhile, the black tree trunks create graphic accents that reinforce the spacious feeling of the landscape.

3. The strength of the contrast between the warm and cool colors has been taken as far as possible, and the finished painting has great strength and vivaciousness.

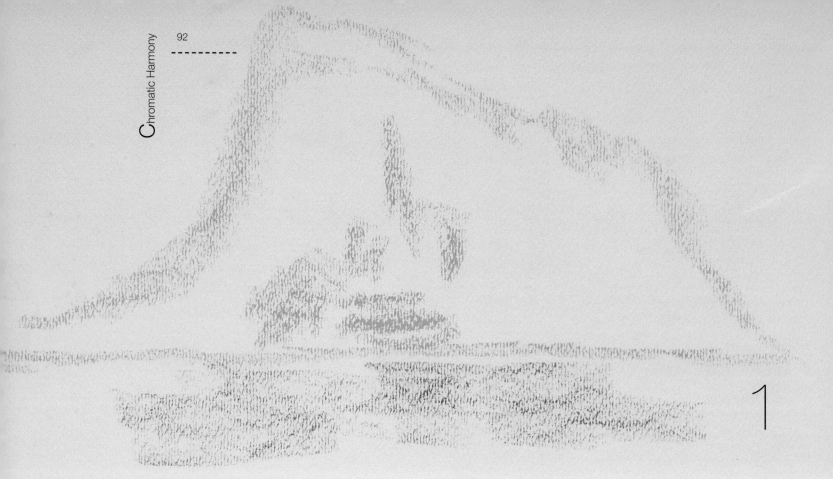

1

Complementary
Colors

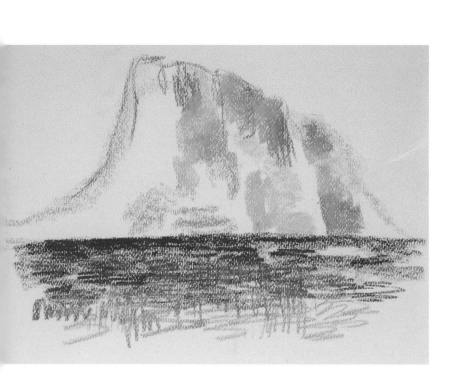

2

Blue and orange are complementary colors, as are red and green, and violet and yellow. This forms part of basic color theory. Complementary colors become stronger when they are placed next to each other. If painters are able to insert two complementary colors in opposition in a painting without harming the nature of the subject matter, they will be able to achieve a more attractive and lively chromatic contrast. At this point, the logic of color should be set aside in favor of personal sensitivity, because at the moment of truth, pairs of true complementary colors are never exactly those stated in theory. They are determined by each situation and subject, because the shades will always vary.

1. The drawing of the subject is very simple: a horizon dominated by a large promontory. The drawing was made with wide strokes of blue pastel and some small strokes to indicate the basic contrasts in the water.

2. The colors of the rock are yellows of different intensity mixed with reddish tones. The tendency is an orange color with many shades. The sea is also painted by superimposing different kinds of blue, with denser strokes toward the horizon.

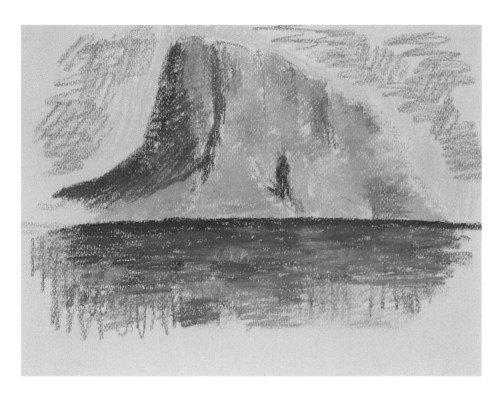

3. Pink was added between the yellows to keep the color from suggesting a totally flat surface, each shade expressing relief in the rock. The accumulated lines in the sea add density to the mass of color, and lighter blues were painted in the sky.

4. The rock and the sea have several layers of color. Fixative was sprayed between each of them to add solidity to the color. The chromatic effect is very bright and luminous, thanks to the contrast between the complementary colors.

3

AN EXERCISE IN COMPLEMENTARY COLORS

This work makes use of the opposition between two complementary tones, yellow oranges and blues. This means that many colors were used, but were grouped around those tendencies that form, in fact, a contrast of complementary colors. The subject is a rocky peak seen from the coast on a sunny day. The rock has very warm tones, and the sea and sky are clean and vibrant blues.

4

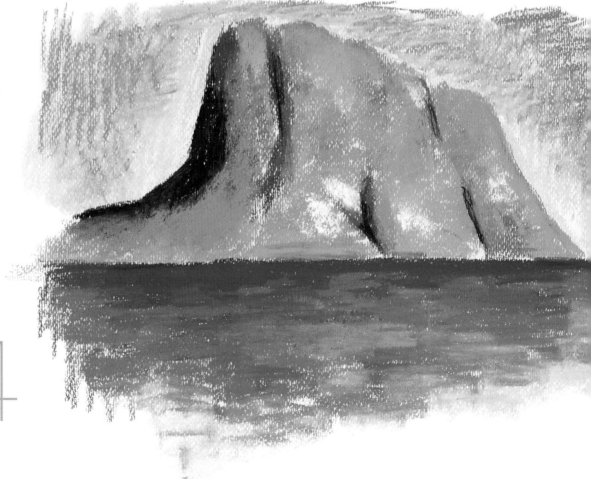

Color Harmony in the Cool Ranges

The cool colors are all those related to the blues, the blue greens, the dark violets, the mauves, and the grays tending toward green and blue. All these colors, placed in relation to the warm colors, seem to recede from the viewer and create a psychological effect of tranquility, quiet, and coolness. The cool tones also depend on the colors found around them, so a blue will seem even cooler when more warm tones are used in the composition.

COLORS AND DISTANCE

Generally, the cool colors always suggest distance in relation to the foreground of the painting. This phenomenon was exploited by the Expressionist painters to discard the use of perspective in their works. They and all the painters who learned their lesson understood that it is enough to cool down a color to make it seem to recede and to evoke a shaded area in the subject of the painting.

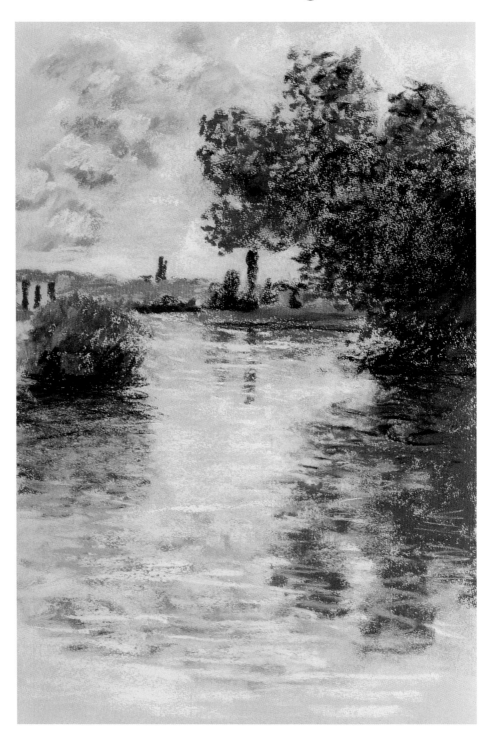

In landscape painting, the cool colors are a direct translation of the weather in the subject. These cool ranges contain multiple warm colors that enrich and add counterpoint to the dominant blues and greens.

VARIETY IN THE COLOR RANGE

In these works we see more neutral and even warm colors, which add variety to the work. You must always consider adding another series of colors to the color range as long as they are not the dominant colors. This is the case of the light pinks, which harmonize magnificently with the blues and grays, but that used alone as the protagonist of the painting would create a warm tendency. The same is true of the yellow greens, which harmonize completely with the blues and grays.

The presence of warm colors as contrasting factors is almost inevitable in work painted in cool ranges. Here those warm colors are limited to the foreground, quite a usual practice in landscapes.

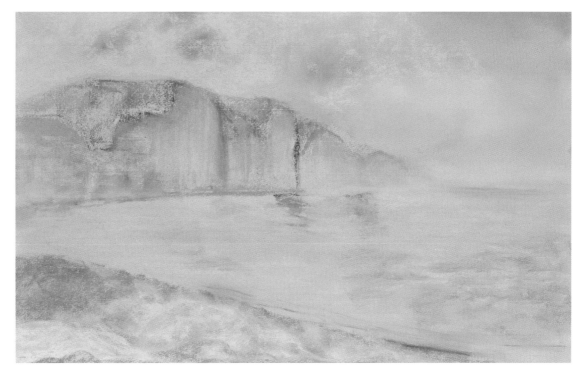

The yellows and oranges in the foreground complement the overall cool tones of this seascape and add a particular lyricism to the atmosphere.

Laying Out a Work with Cool Colors

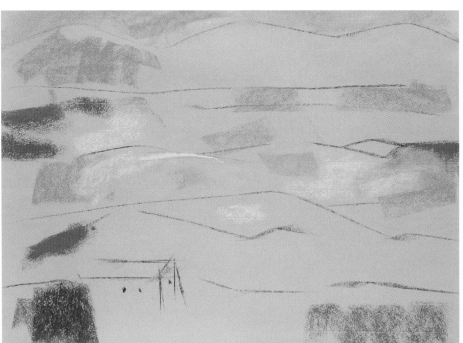

We find more reasons for using very defined ranges of colors when painting landscapes. In this exercise the cool ranges of a winter landscape are required: a large number of grays, among which figure some warm tones, although not very saturated. For an artist, grays are colors in their own right, and they make up the largest family of colors imaginable. Most of the grays used here are a mixture of white and bluish gray, or just a direct mix of white and black.

1

1. This range is dominated by neutral grays along with a few warm light pinks and yellows in the center of the composition. The drawing of the landscape is very elementary, and all the interest is created by the play of the areas of color.

2. The dispersed strokes of color can be unified by lightly blending some white color with them. The lines that mark the different grounds of the landscape are the only places where the shading is clearly separated.

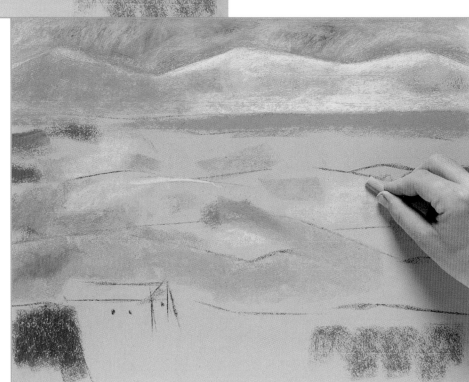

2

3

MIXING WITH GRAYS

The grays are the foundation for well-developed harmony for all but the artists who work in very strong colors, because they are used to soften and coordinate the contrasts between the saturated colors. The gray ranges become very interesting when you consider all the shades that can be created by mixing all sorts of colors with black and white. The grays multiply the ranks of color harmonies because they increase the reach of each color by reducing its saturation with either white or black. You must keep in mind that many colors change when they are grayed. Thus, yellow tends toward ochre and green, orange toward brown, and red toward purple. But this is less an inconvenience than an incentive for the artist who likes personal and imaginative color harmonies.

3. The rooftops of the small houses that appear in the center of the landscape add warm notes of color to the composition.

4. The intonation is truly cool and is accented by a sober and quiet composition. These factors create a typical wintry landscape.

4

Neutral colors are the "impure" tones, the ones that tend toward a full color but do not get there. These "broken" colors are the green ochres, brownish reds, earth greens, dark green blues, the browns, and so on. The names used to define them show that these tones are not as pure as the saturated primary colors. They can have both warm and cool tendencies, leaning toward one or the other.

Neutral Color Ranges

MUDDY COLORS

Painters refer to colors that are dirty as *broken* or *muddy*. These result from mixing saturated colors with black or white, or with their complementary colors. Mixing complementary colors in equal parts creates a dark gray, but if the proportions of both colors in the mix are very different, the result is a neutral or broken color. Mixing too many combinations of tones muddies colors, and continued use of broken colors can ruin the harmony of the work by creating a turbid effect. But when used in the right measure, neutral colors are a very efficient way to emphasize the intensity of the saturated colors and to soften their bombastic effect, or even to achieve an atmosphere that is calm and harmonious.

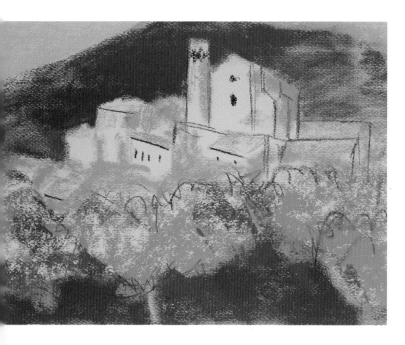

All neutral colors have a specific chromatic tendency, either warm or cool. In this work the tendency is warm, although there are no truly intense warm colors.

In contrast to the darkness of the tree, the background of the landscape has a light tone. It is composed of grayish blues that are darker on the horizon.

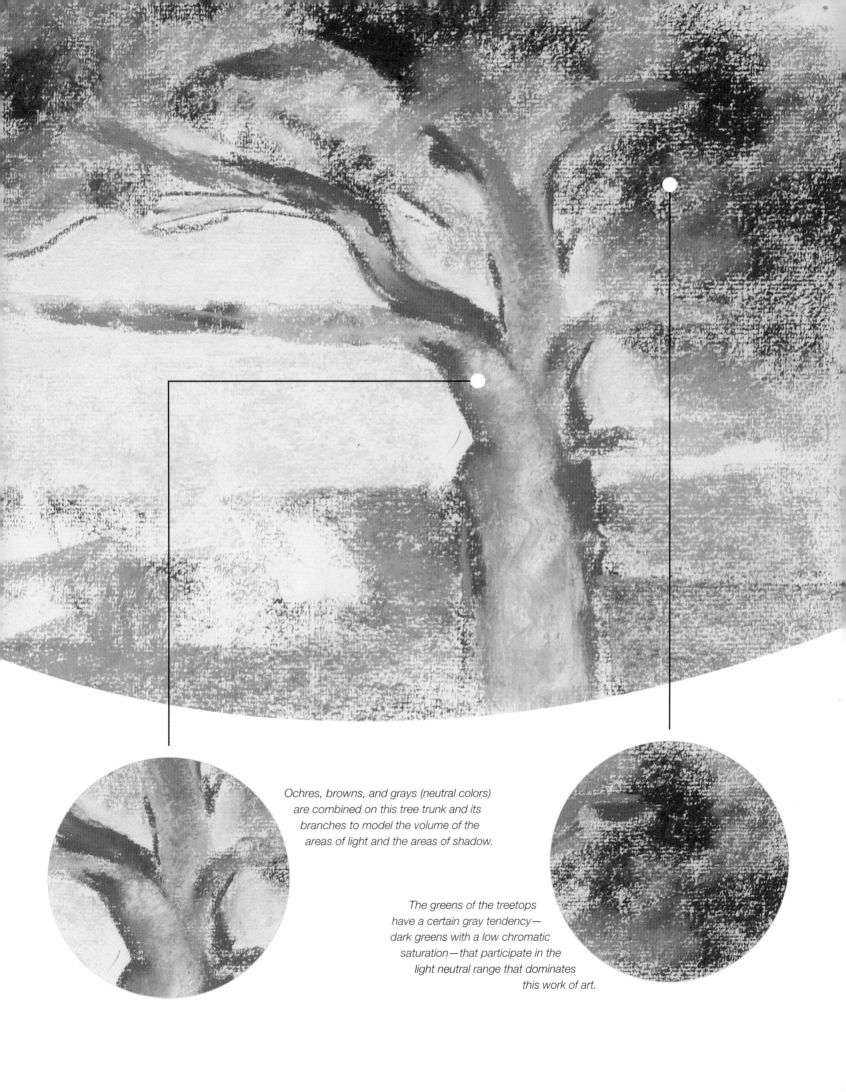

Ochres, browns, and grays (neutral colors) are combined on this tree trunk and its branches to model the volume of the areas of light and the areas of shadow.

The greens of the treetops have a certain gray tendency— dark greens with a low chromatic saturation—that participate in the light neutral range that dominates this work of art.

Chiaroscuro with Color

The contrasts between a light and dark tone, or even between light and dark variations of the same color, can also be expressed through the contrast of different colors. Usually you would try to use warm and cool colors in opposition (understanding that the warm colors will be lighter than the cool ones), to emphasize the color and luminosity of the work. This way you do not have to sacrifice the use of a variety of colors to express volume. This is the method used by the Impressionist painters, who discovered that it was not necessary to add gray to the color of an object to create a shadow; it was enough to make it cool. Thus, blues, violets, and greens fill the areas that were before occupied by somber tones, the shadows became light, and the color harmony became much richer.

SPACE THROUGH CONTRAST

Keeping in mind this factor of distances between colors, you can create your pastel by thinking of treating the background with cooler colors than the foreground of the composition. Another way of suggesting space is to contrast values or intensities. These contrasts should be strong to get good results, otherwise they will become lost in the usual and common shading of the color. For example, a very dark form against a light background advances toward you in the same way that a very light form against a dark background appears closer. This is because nearby forms have more contrast. This contrast can be combined with that which exists between warm and cool colors to reinforce the space in the painting even more.

1

2

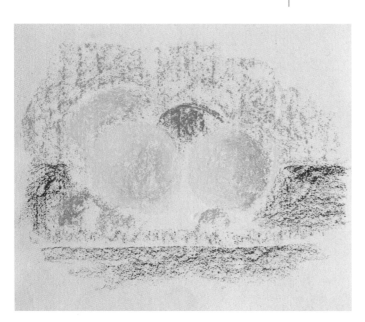

1. The layout of this small still life consists of some pieces of fruit in very light colors (and very saturated) contrasted against a dark background that also has saturated colors. Blue was added to the play of contrasts to reinforce the intensity of the yellows.

2. Yellows and greens contrast in value (light against dark) and in color. In addition, the color of the table is reinforced to intensify the contrast even more.

3

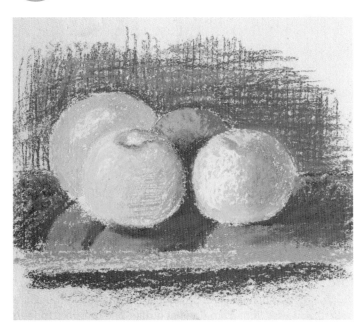

3. The sense of space, of distance between the fruit and the background, is intensified according to how saturated the color becomes as more is applied.

Contrasting colors is a technique used by all the colorist painters to create a feeling of space in their work. In this painting, the light values of the objects stand out against the dark background.

4. Finally, a convincing expression of distance and space, and volume as well, has been created without resorting to conventional chiaroscuro. The work was completed using only contrasts of pure color.

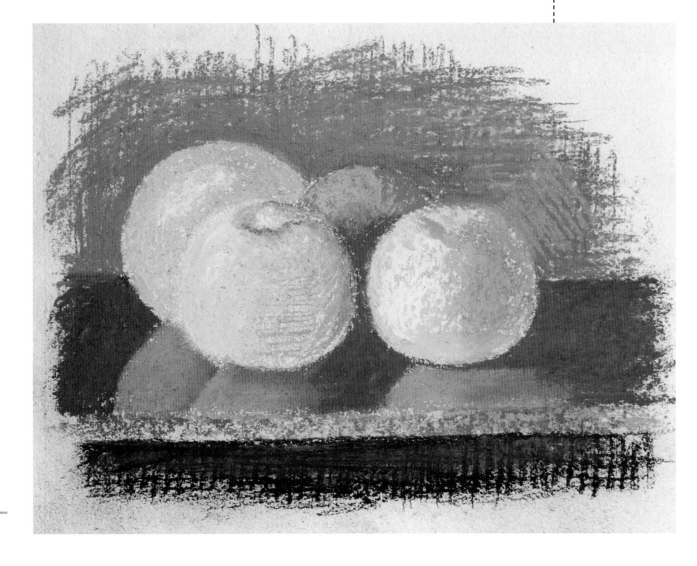

4

Pastels and the Human Figure

"WHAT DISTINGUISHES A GREAT ARTIST FROM A WEAK ONE IS FIRST THEIR SENSITIVITY AND TENDERNESS;
SECOND, THEIR IMAGINATION, AND THIRD, THEIR INDUSTRY."
John Ruskin (1819–1900).

3

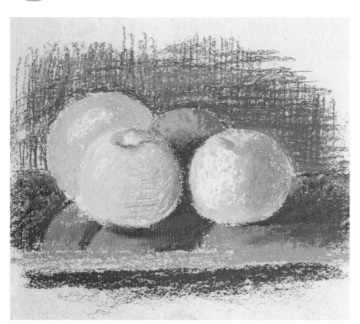

3. The sense of space, of distance between the fruit and the background, is intensified according to how saturated the color becomes as more is applied.

Contrasting colors is a technique used by all the colorist painters to create a feeling of space in their work. In this painting, the light values of the objects stand out against the dark background.

4. Finally, a convincing expression of distance and space, and volume as well, has been created without resorting to conventional chiaroscuro. The work was completed using only contrasts of pure color.

4

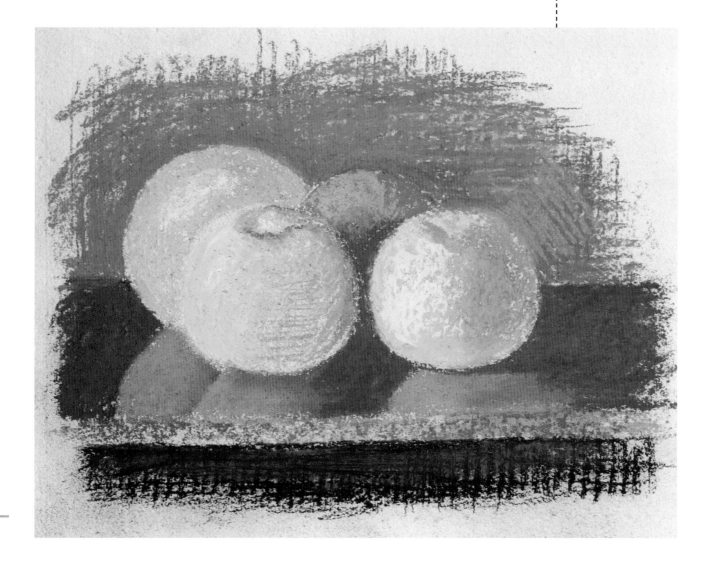

Pastels and the Human Figure

"WHAT DISTINGUISHES A GREAT ARTIST FROM A WEAK ONE IS FIRST THEIR SENSITIVITY AND TENDERNESS;
SECOND, THEIR IMAGINATION, AND THIRD, THEIR INDUSTRY."
John Ruskin (1819–1900).

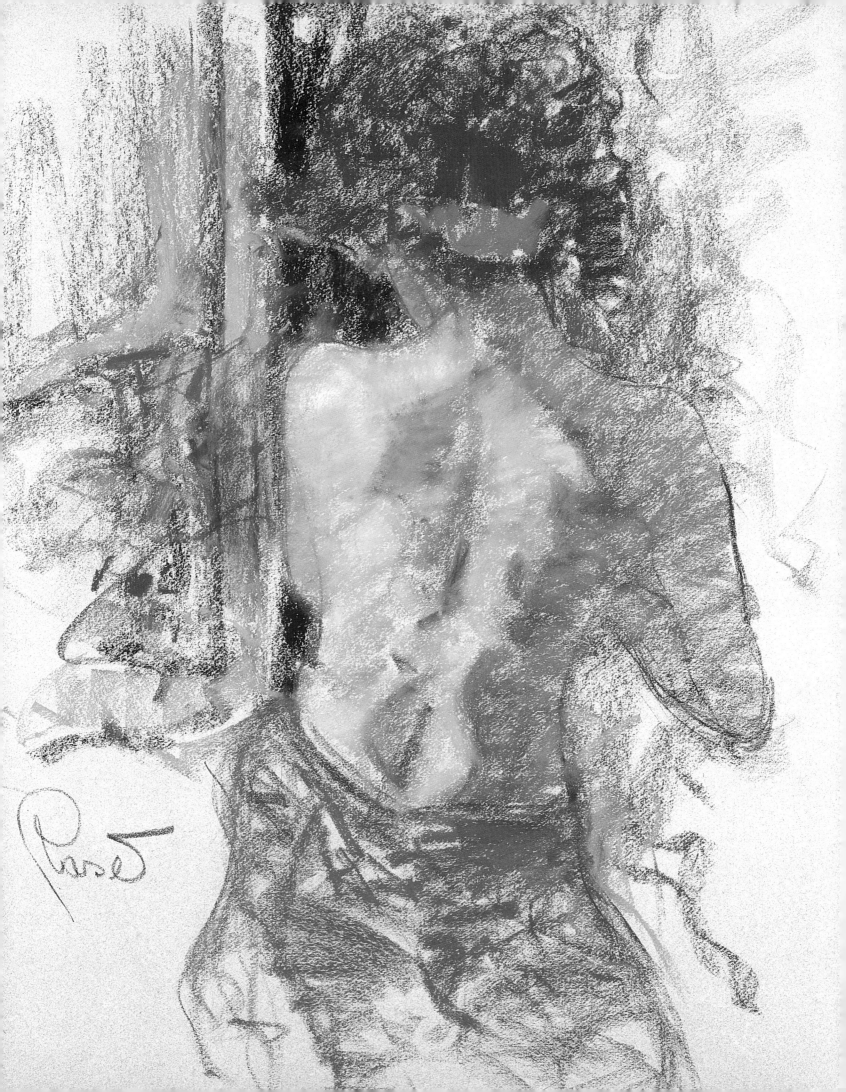

A Great Subject for

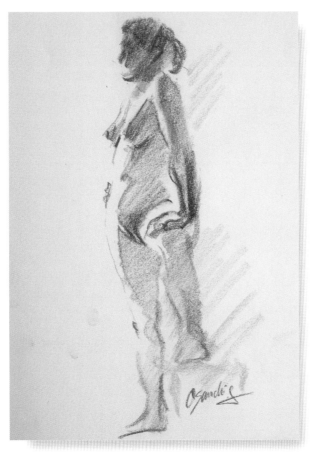

Pastel Artists.

The nude is the greatest subject of the pastel artist

(and of most painters). The texture and consistency of pastels are perfectly adapted for this theme, which is why it merits a separate chapter in this book. The human body is infinitely richer than any other painting subject, and it offers colorations that seem to have been created expressly for pastel paints. This fact, among other factors associated with the human body, affects the work of painters in a way that makes them want not only to represent the external appearance of the body but also to express its humanity.

The Medium and the Subject

For lovers of pastel, this is the most sensual technique of all, because it affords the artist a more direct and physical contact with the substance of painting, a manual contact with no tools in the way. Perhaps this is why pastel painting has become the favored medium for drawing and painting the human body. In any case, the representation of the female nude holds a privileged position in the tradition of pastel painting. The velvety, matte, and warm aspects of pastels are without a doubt extraordinarily appropriate for treating the nude.

The soft modeling required by the female nude is very easily done using pastels. The figure can be constructed quickly and efficiently by spreading a few areas of color.

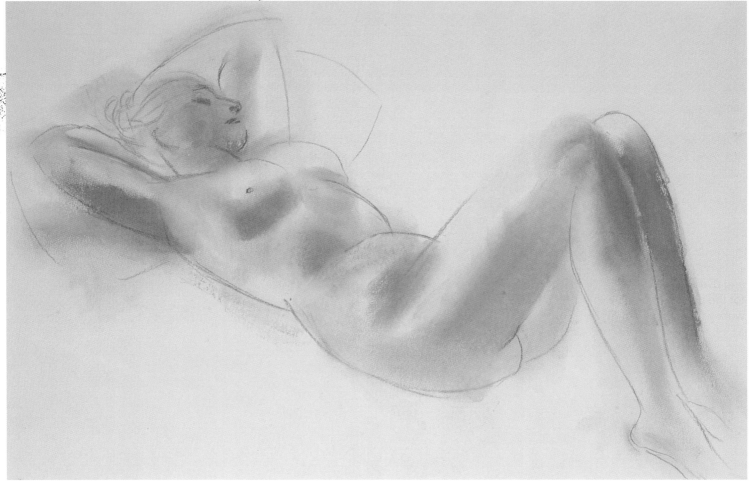

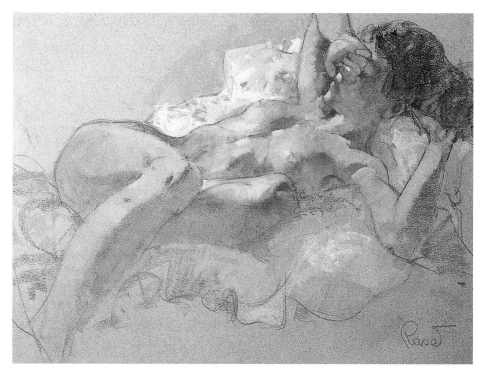

The finished forms do not necessarily indicate the artist's laziness. Sometimes it is a good idea to leave just an indication of the form, a sketch, so that it does not distract the viewer. But this unfinished form should contain enough indications to be easily "understood" and reconstructed in the imagination.

The modeling here was carefully constructed to create an attractive composition that affects the most relevant parts of the figure. The rest was left partially unfinished but clearly suggested.

INTERPRETING THE NUDE

When an artist observes and studies the body of a model, he is selecting artistic features, separating them from everything that lacks aesthetic possibilities. Experience with pastel paints will cause you to choose, for example, certain qualities of color that will be most opportune for combinations of tones, superimposed color, and fresh line work. It will also cause you not to focus too much on details, which are difficult to express with sticks of pastel and are of secondary interest anyway. The ingenuous attitude of "copying everything" makes no sense and results in unexpressive and overworked paintings. Visual selection is fundamental for the painter to be able to carry out loose and relaxed work without constant retouching and additions that can only introduce confusion into the work. The painter sees only what he wants and needs to see.

The subject of the figure is especially appropriate for the characteristics of pastel painting. The softness of the strokes and the purity of the colors of the pastels fully justify their use.

A person with little experience in painting might believe that there is a "flesh color" that can be applied when painting the human body with no complications other than that of actually applying the color to the paper. But the human skin does not have a specific, unchanging color. Obviously, the skin tends toward pinks, light ochres, siennas, and so on—lighter colors in the warm range. The manufacturers of pastels do not offer a stick labeled *flesh*, because they are fully aware that it is the artist who creates the flesh tones in the work of art.

The Color of the Skin

INTERPRETING THE FLESH TONES

The flesh tones of a female nude painted with pastels should always be based on expressing the shadows and light on the anatomy, understanding that the shadows can be deep and dense or light and transparent, and that the light can be intense or filtered and indirect. The flesh tones will vary according to the color that surrounds the figure. If you are working on a cool gray paper, it will be enough to use a slightly warm color, such as a light sienna, for the flesh to stand out with a dark intensity against the background. On the other hand, if you paint on a warm support, you will not have to emphasize the warmth of the figure, which you can paint using very pale pinks, some yellow, and even white.

Each artist tends to interpret the flesh tones in a personal way. Some painters start with orange ochre, a very intense flesh tone, as a base color that is shaded with reds, pinks, and carmine to create a coherent range of strong colors.

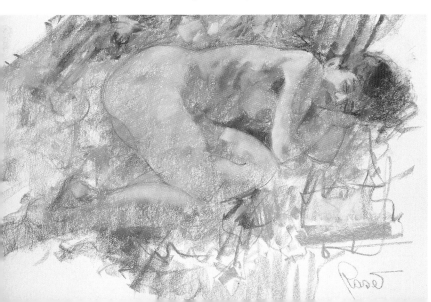

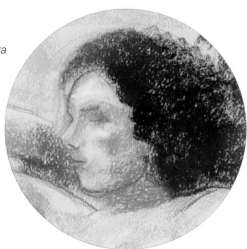

Touches of magenta are clearly placed on the face of the figure and not only help model the figure but also add liveliness to the expression.

Orange, burnt sienna, and pink are the colors used for the shaded flesh tones. They are not completely blended so as not to create a solid heavy tone, and to allow the white of the paper to show through the strokes.

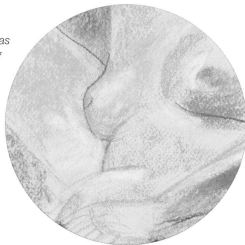

The lightest areas are composed of pinks and light ochres softened with white and lightly blended to add volume to the modeling.

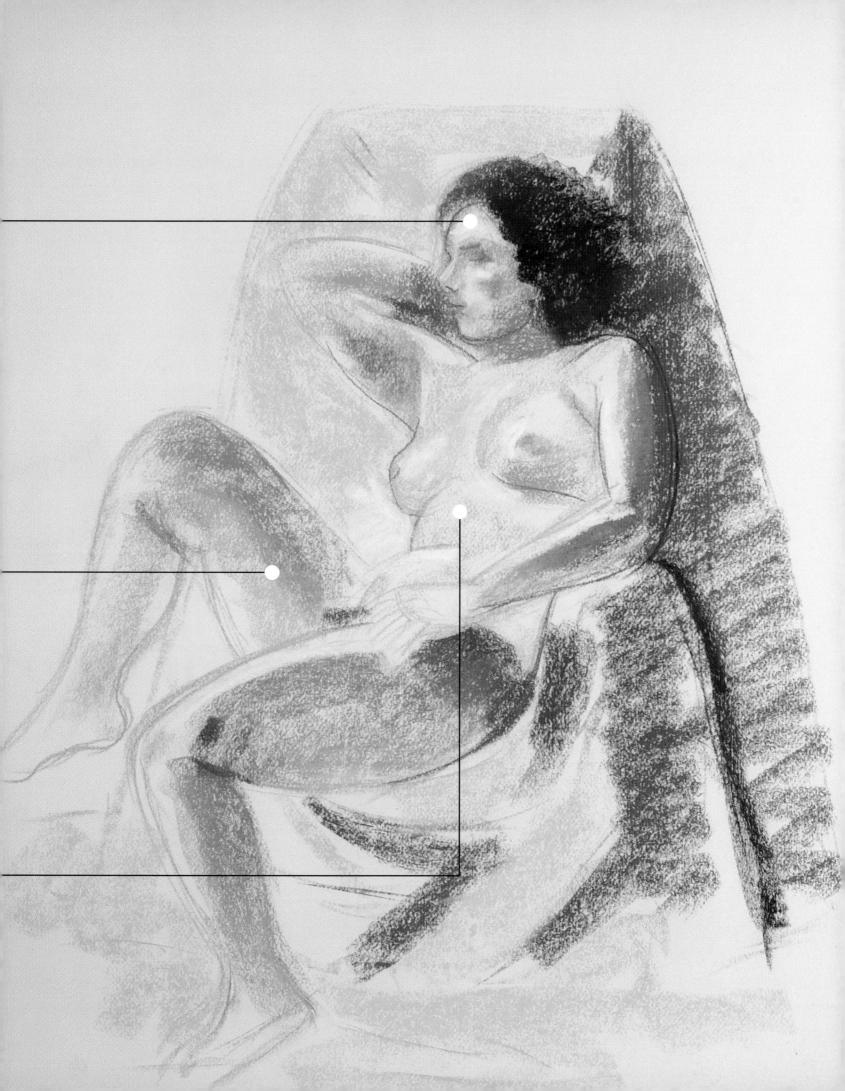

Notes and Sketches
of the Figure

Pastel painting with either pencils or traditional sticks is an ideal medium for making sketches of the figure from life. The sticks can be used to express the movement of the figure with a few well-placed strokes, alternating different contrasting colors or a single stick to interpret the nude in a monochrome sketch. Working with pastel pencils is much like sketching with graphite lead pencils. Pencils have a very agile line and are easily used to create alternating areas of simplicity with detailed areas.

The line made with a pastel pencil is sweeter than that of charcoal and warmer than common graphite. This drawing is a splendid example of synthesizing the anatomy of a female nude.

This quickly captured image has an agile and cursive style where everything is reduced to a synthesis of lines. Only the details necessary for understanding the form and the articulation of its members are used.

REPRESENT ONLY THE ESSENTIAL

Making rapid sketches is no more difficult than making a normal drawing. The issue of color becomes subordinate to capturing the pose, the essential lines that define it, and eventually the play of light and shadow indicated in a general way without details. You can work on any drawing paper of small or medium size, and you do not have to use colored paper. When working on a sketch, you do not need to make corrections or be very elaborate. When the result is not what you want, it is better to start over. The ultimate objective of making rapid sketches is to find the best pose and composition for your needs, and also to exercise your hand and eyes. Therefore, the more loosely you work, the better.

The synthesized style of the figure sketch done with pastel sticks is based on the overall effect of the strokes. There are no details or outlines, only a mass of lights and shadows that suggest the form of the head and the facial features.

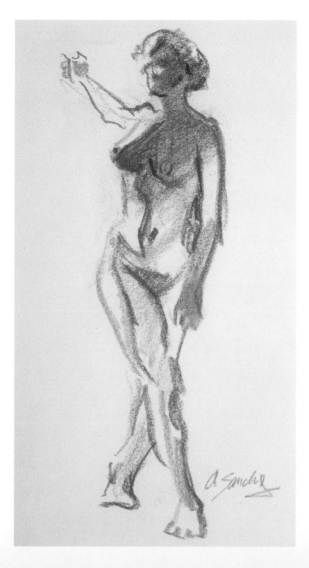

When working with soft pastels, the synthesis or simplification should be greater than when you are using pastel pencils. The lines should be bold and not show any hesitation. Synthesis is not only a matter of lines, but also of areas of color and the distribution of light and shadow.

This sketch combines pastel pencil lines and strokes of soft pastel sticks. The artist Óscar Sanchís used highly contrasting colors (blue and orange) to achieve lively, strong results with just a few applications of color.

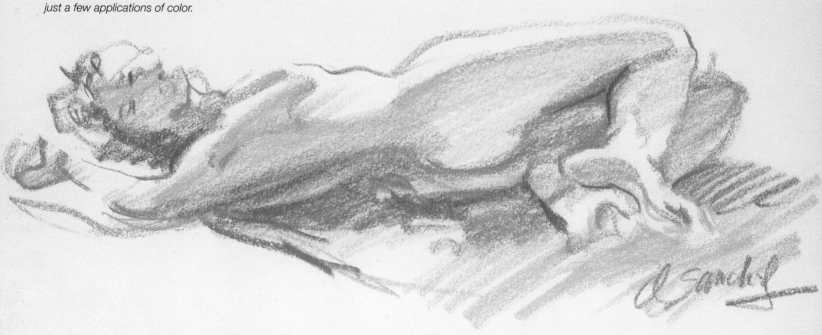

Making a Sketch with Pastel Pencils

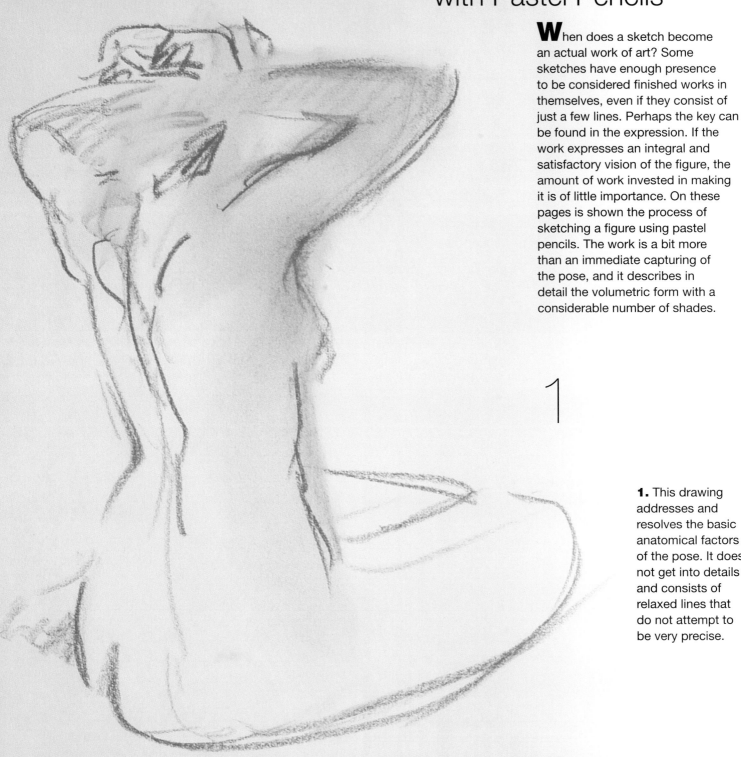

When does a sketch become an actual work of art? Some sketches have enough presence to be considered finished works in themselves, even if they consist of just a few lines. Perhaps the key can be found in the expression. If the work expresses an integral and satisfactory vision of the figure, the amount of work invested in making it is of little importance. On these pages is shown the process of sketching a figure using pastel pencils. The work is a bit more than an immediate capturing of the pose, and it describes in detail the volumetric form with a considerable number of shades.

1

1. This drawing addresses and resolves the basic anatomical factors of the pose. It does not get into details and consists of relaxed lines that do not attempt to be very precise.

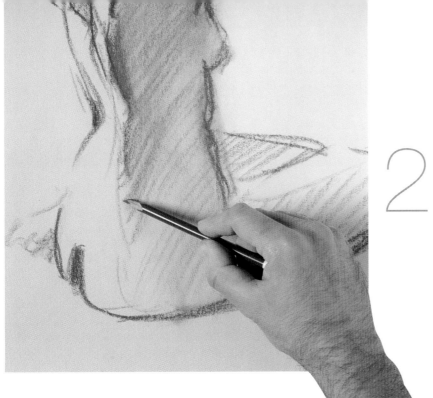

2

2. The modeling within the anatomy is done with a sanguine pencil. This takes little time; it is a matter of emphasizing the most relevant lines (spine, shoulders, neck, and so on) and shading the dark flank of the figure with light lines.

3. The sketch resulting from this process is loose and delicate at the same time. The careful changes in the pressure applied to the sanguine pencil during the shading creates the delicacy of the drawing.

FROM THE OUTLINE TO THE VOLUME

If artists have enough time, they usually divide their work between an initial sketch of the pose and a simple finish. The initial drawing is basically blocking in lines that indicate the proportions of the parts of the figure in a stable and well-proportioned composition. In this exercise the artist made the drawing with a blue pastel pencil that clearly contrasts with the warm tones that will later be used. These tones are no more than shades of the same color: red oxide or sanguine, a very popular color among draftsmen and quite useful for making sketches. Different intensities are achieved by changing the pressure applied to the point of the pencil, which can be used to develop the modeling that is done with simple lines.

3

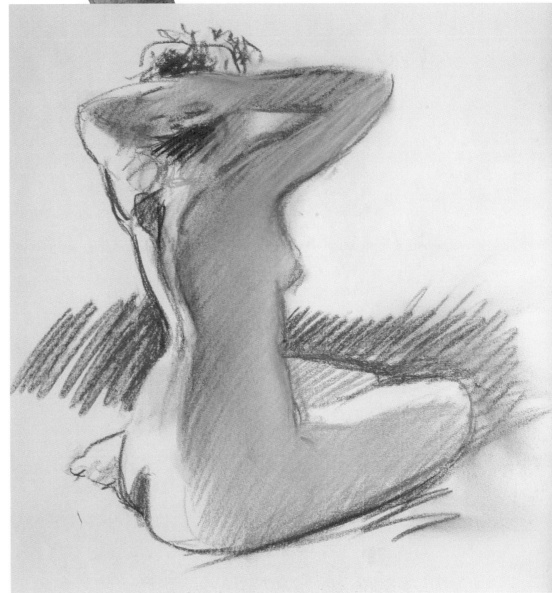

Making a Sketch with Soft Pastel Sticks

1

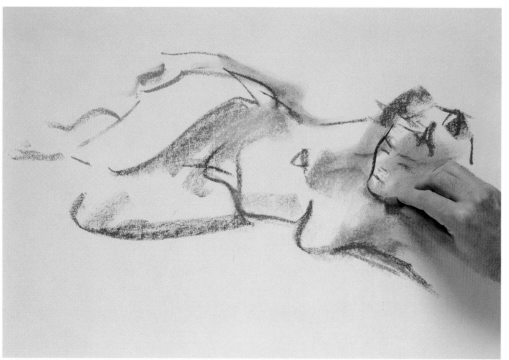

Pastel sketches consist of wide strokes made with pastel sticks and the small size paper that is customary for these exercises. These conditions oblige the artist to suggest the anatomy, to abbreviate the form—in other words, to synthesize. There is no chance of working in detail or of precisely adjusting the outlines. Here, the initial sketch is a sort of shorthand, a group of lines acting as signals that indicate the anatomy more than represent it realistically. The fresh and spontaneous look of the drawing can be attributed to this. The shading is equally spontaneous, and to achieve it the color was applied in a general manner without fear of crossing the previously drawn lines.

2

1. The thickness of the sticks used on a small piece of paper makes it impossible to address the smallest details of the figure. The initial drawing uses only graphic signals to block in the basic volumes—the legs and trunk of the figure.

2. The shading is applied using various warm tones such as sienna, orange, red oxide, and so on. The resolution of the shading does not carefully follow the edges of the drawing, but consists of accumulating the colors where the shadows appear and leaving the lightest parts of the figure alone.

FORESHORTENING

A foreshortened figure is seen "in perspective." Its proportions seem deformed because of the point of view from which it was painted. Foreshortening is a technique typically addressed in the teaching of drawing and painting. Besides its academic interest, it can be a highly effective artistic approach if it is used with understanding and, more important, with naturalness. Most of the poses painted by an artist contain some foreshortening, because there will always be an arm or a leg, a neck or a shoulder that is seen in foreshortening. Here, the foreshortening of the calves and the trunk were resolved very skillfully.

The speed of the process and the size of the pastel sticks do not allow for details. They are more appropriate for spontaneous treatments of the subject.

3. Some strokes of cool color were applied to the figure to emphasize the highlights, which are the untouched white of the paper, and to create contrast between complementary colors—the blues in the background and the oranges of the flesh tones.

3

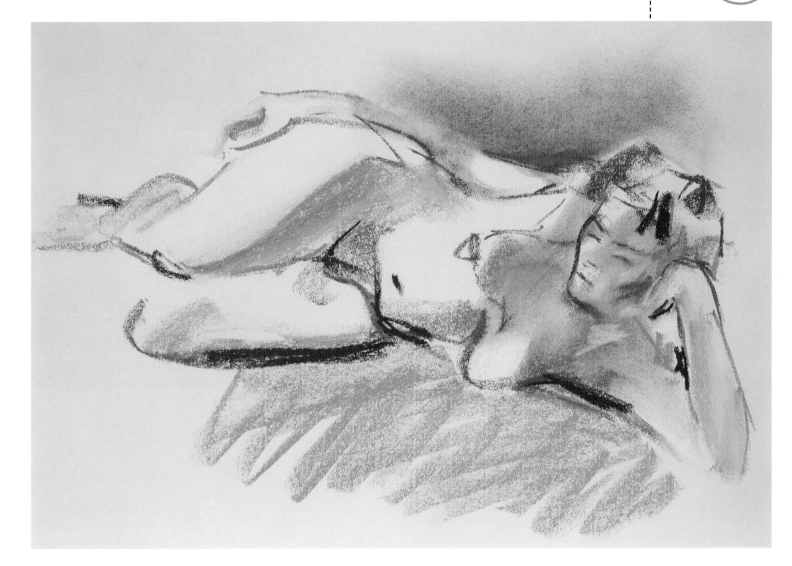

Step-by-Step

"EXPRESSION DOES NOT RESIDE IN THE FEATURES OR THE GESTURES OF A FIGURE BUT IN THE OVERALL ARRANGEMENT OF THE SHAPES AND COLORS OF THE WORK, REGARDLESS OF THE THEME."
Henri Matisse (1869–1954).

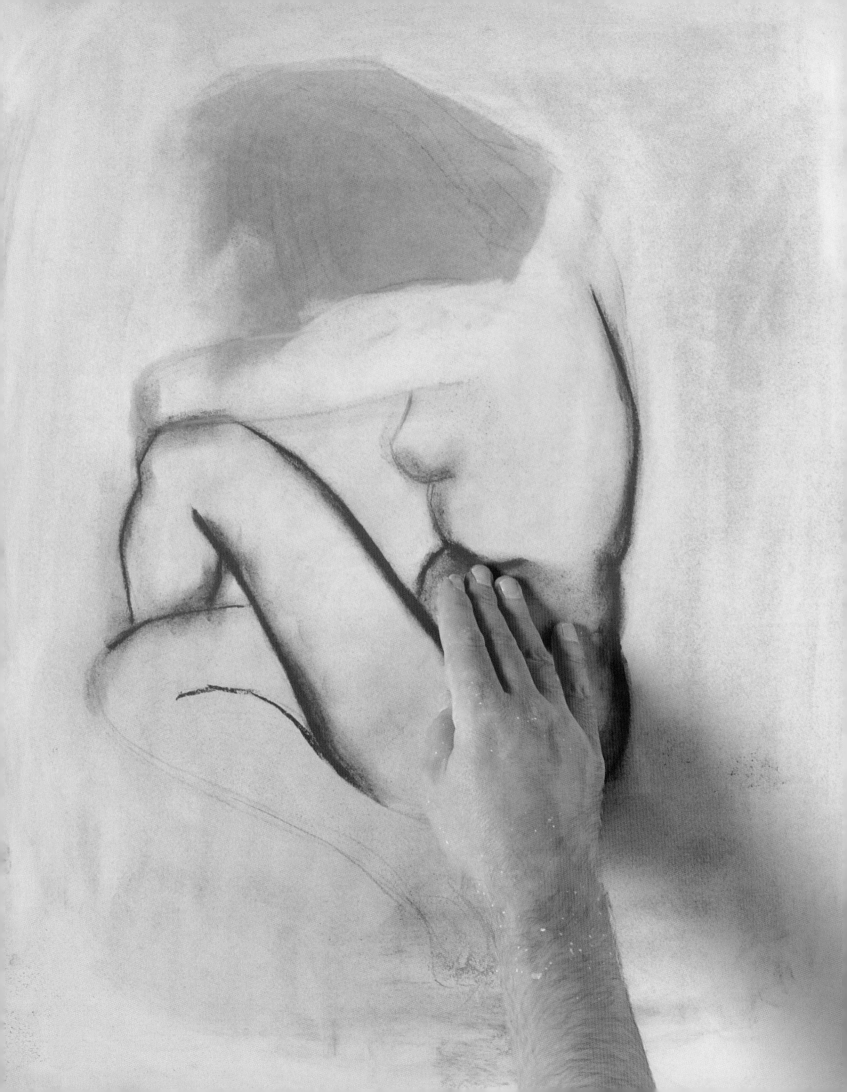

Lines and Hatching in a Colorist Still Life

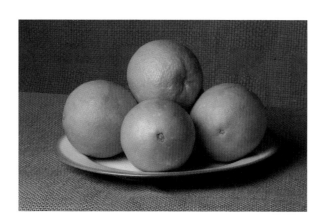

One of the principles that guided the work of Impressionist master painters was the translation of values and chiaroscuro into colors, avoiding gray tones and neutral colors in favor of polychromatic harmony. In this subject tackled by David Sanmiguel shadows are treated as pure color. Contrasting warm and cool tones replace the contrast between saturated and gray or neutral colors. The style is essentially pictorial and very rich in the contrasts of hatch lines and solid areas of color.

1. The artist begins by identifying the placement of each element as well as its characteristic color by applying a few strokes without a preliminary pencil drawing. This is an indication that the painting is going to be basically colorist in style.

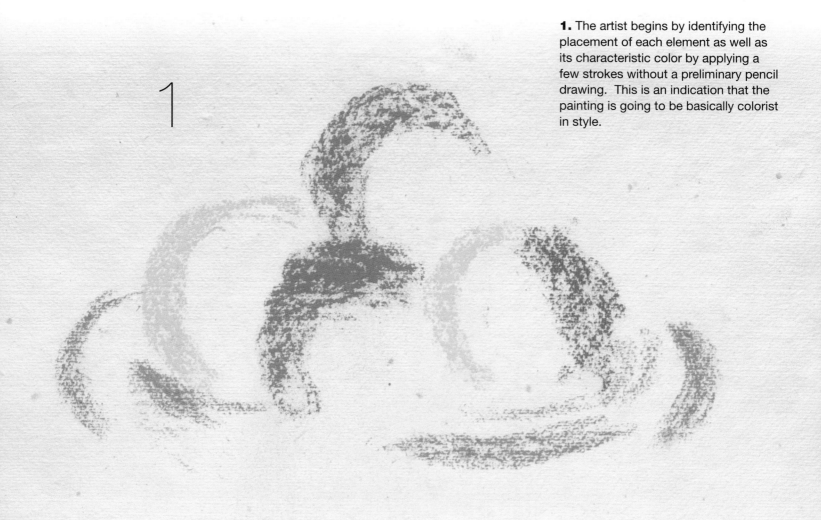

1

The paper used for this work has a lot of texture and the colors do not cover the surface completely, which is why the work has so many saturated colors.

2

2. The fruit is painted with a variety of reds that are first applied with wide strokes and are later completed with hatch lines.

3. The heavy grain of the paper retains a lot of the pigment and makes the colors look very saturated, even the lines and hatch lines. Those hatch lines are drawn with the same colors of the fruits mixed with blue and mauve tones. Each color stands out by itself without blending in completely with the rest, creating an optical mixture.

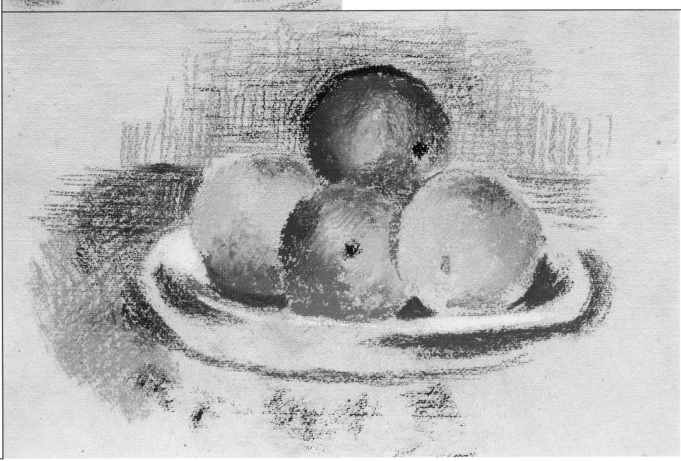

3

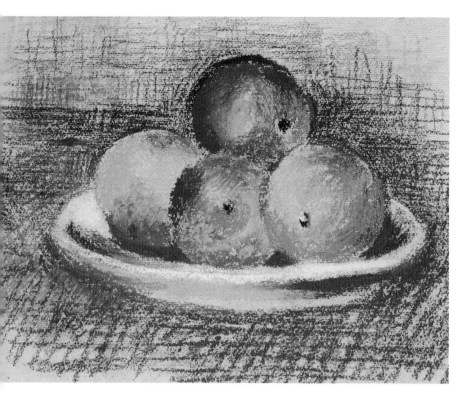

A

4 **4.** The great chromatic strength of this painting is the result of using pure contrasts: red against green, and blue against yellow. In addition, the contrast is reinforced by darkening the colors in the areas where they touch each other, strongly emphasizing the volumes.

THE ARTIST COMMENTS

Intense chromatic results have been created with just a few colors, thanks to the great amount of pigment retained by the highly textured paper and the clean contrasts. No gray tones were used, and all the modeling was done with saturated colors as can be seen on the fruits (A). The plate was suggested with just a few blue lines of very saturated color (B). All the colors that form the background of this composition are made with hatch lines, which creates very light contrasts while avoiding colors that are too solid (C).

B

C

Between the Seascape and the Cityscape

In this work, painter Óscar Sanchís developed a theme that is halfway between a seascape and a cityscape, a subject matter that is very luminous but of chromatic simplicity. The foreground with palm trees calls for a graphic approach using lines, and the background with the sea and the sky suggests the use of solid blocks of color. We will see how the artist resolves these color and form elements decisively.

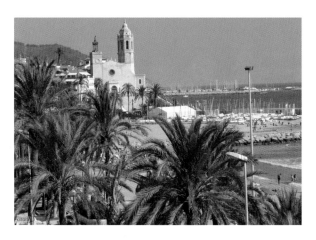

1. The theme has been sketched out with a series of charcoal lines that lays out the scene with minimal use of resources.

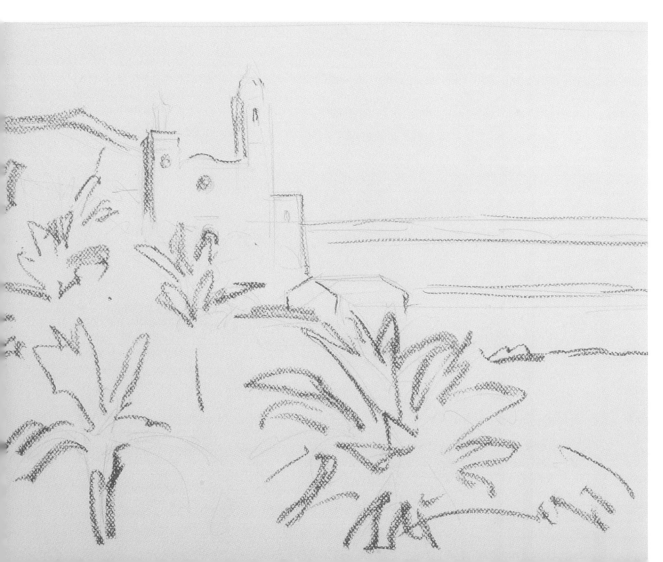

1

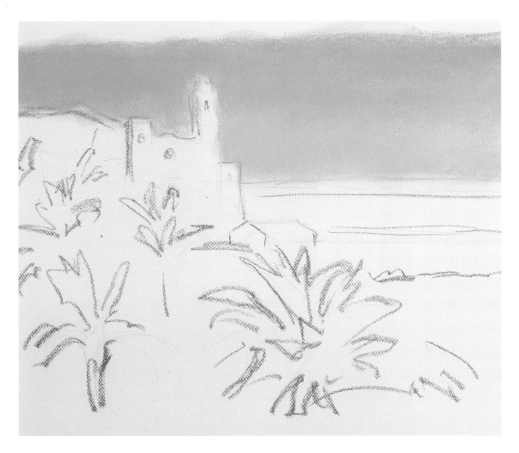

For the minute details of the port, the artist uses white pastels to paint the masts on the boats, which stand out against the blue sea.

2. Right after that, the sky has been covered with medium blue (spread with the fingers until all the paper has been saturated), which will be the only treatment for this part of the composition.

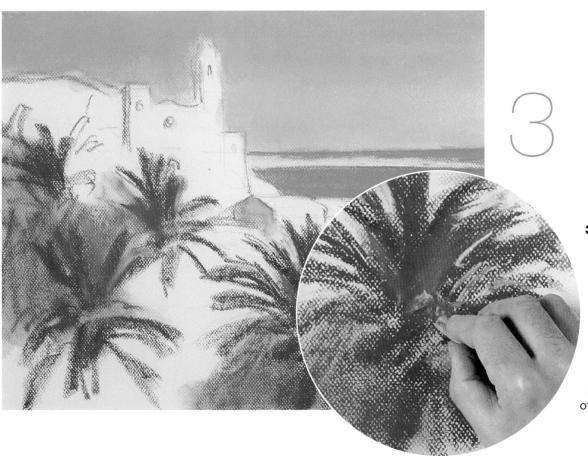

3. With the same dexterity and agility employed in the charcoal drawing, the artist now tackles the palm trees with large strokes of a single tone of gray green that is partially blended. A few light details of orange color are enough to suggest the warm tones of the dry leaves.

4

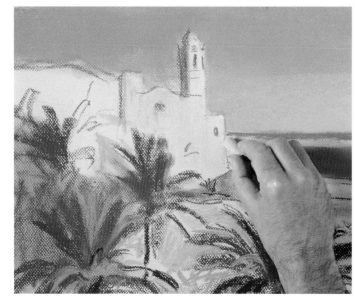

4. To avoid depriving the painting of luminosity, the artist paints the buildings with very light, almost white, pink, without getting caught up in the details. The same color is used to paint the coastline and the jetty.

A

THE ARTIST COMMENTS

This pastel was executed with outstanding agility, proof of which is the quick and concise approach that can be seen on each detail, especially on the palm trees (A), where the strokes of green color are combined with blue, creating an Impressionistic effect full of light and vitality. The synthesis of the details can be seen in the beach area (B); here, the figures are reduced to small touches of dark color, and the waves are suggested with simple strokes. Finally, the port (C) is also an example of synthesis of form and color within the Impressionistic flavor of the scene.

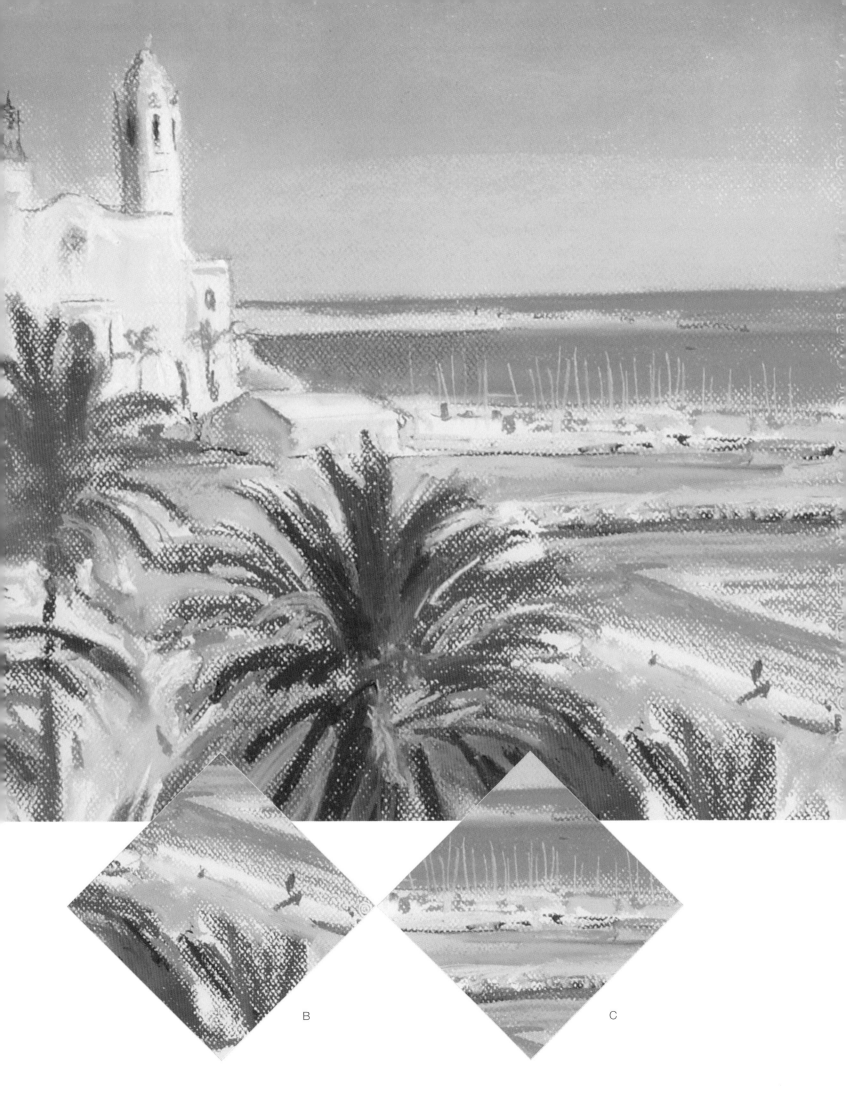

B

C

Value and Color in a Still Life

The most interesting aspect of this simple theme, which was handled by David Sanmiguel, is the combination of areas of light and shade that are present in the background, which forms an interesting mosaic of geometric values and shapes. Those shapes are the result of the different shadows projected by the windows and the architecture of the room, light and dark values that provide a perfect background for this still life.

1. The theme is drawn in charcoal without applying too much pressure on the paper. These lines should be as simple as possible and should provide the placement and outlines of each element of the composition so that each one can easily be painted later.

1

2

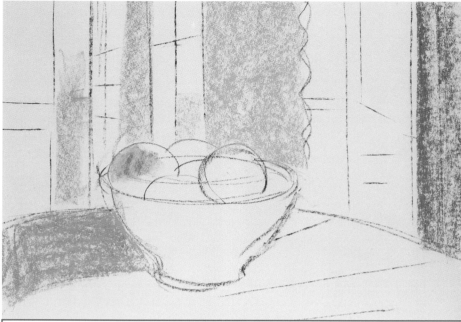

3

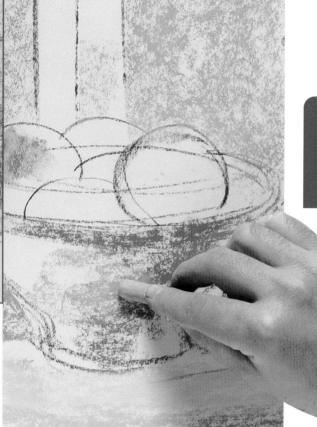

2. The color is applied with the flat side of the pastel stick on the paper.

3. Cool and warm colors are used to model the bowl, applying them in such a way that the lightest values blend with the darker ones, creating the round effect of the volume.

4

4. Different neutral tones are used: blue grays for the background and warm grays for the surfaces in the foreground. The warm grays are achieved by superimposing layers of ochre combined with light grays (the lightest areas) and purple combined with dark grays for the darker areas.

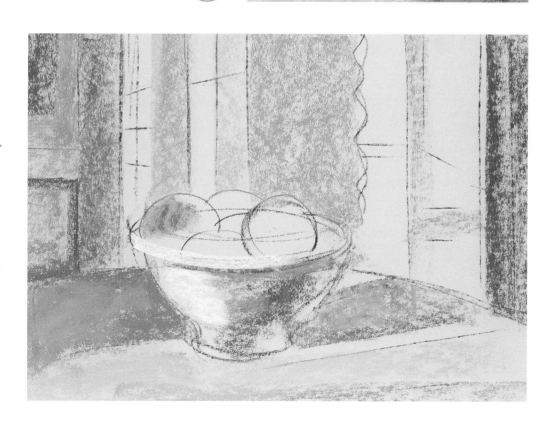

5

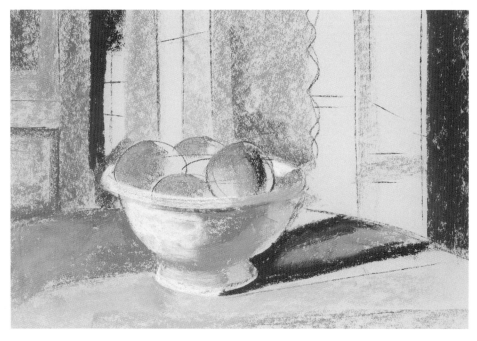

5. All the areas are flat except for the ones that form the fruit bowl. The volume of the bowl has different values: White is used for the direct light and blue for the reflection behind, and the darkest one in the area with the least light is a complex gray with warm and cool combinations.

A

THE ARTIST COMMENTS

The key to the colorist appeal of this painting resides in the liberal combination of neutral tones, which are present in most of the composition where the red and orange colors of the fruit stand out vividly (A). The colors that form part of the neutral scheme of the theme can be appreciated on various elements (B); these colors have not been blended completely so they will stand out. Blues and grays, which have been layered without blending, can be seen in the coolest colors (C).

B

C

Light and Space
in an Interior

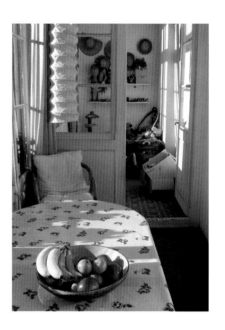

In this motif the artist addresses two different subjects: the interior and a still life. In terms of the space, the interior will fill up the entire painting, but the placement of the fruit is very important from the composition's point of view, and its color is the only warm saturated contrast in a cool and white background. The work is by Óscar Sanchís

1

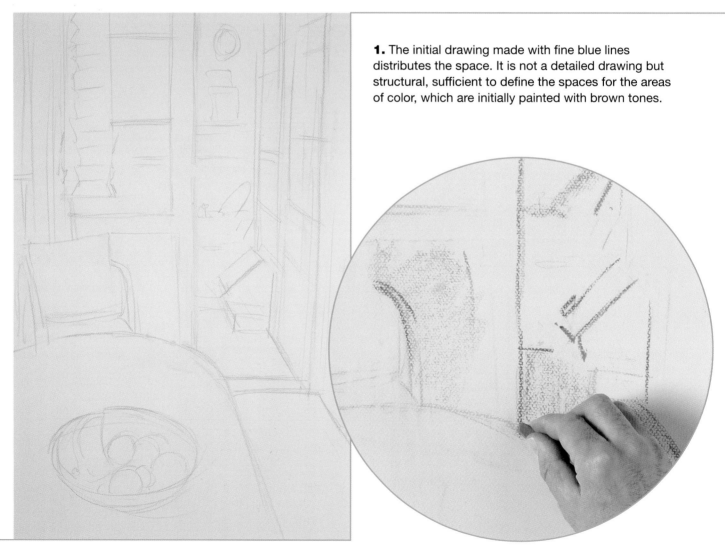

1. The initial drawing made with fine blue lines distributes the space. It is not a detailed drawing but structural, sufficient to define the spaces for the areas of color, which are initially painted with brown tones.

This is the characteristic texture of a Canson Mi-Teintes paper, a mechanical and regular texture that is very visible under the soft colors of pastels.

2

3

2. The color is applied to the paper with the flat side of the pastel sticks to spread it easily. This approach lets the texture of the paper, which is thick and quite rough, come through.

3. Only two tones of color are applied to the areas that have no light: burnt sienna and light blue. The overall space in the room and the placement of all its main elements have been defined with a few areas of color.

4. The areas of previously applied color are now blended with the fingers. Specifically, the shadow of the lamp is blended to create a darker area in the center (right next to the brightest area) and a little lighter area in the back.

5. Without changing the initial distribution of the different areas, the artist consolidates the color by adding several touches of blue.

6. The outlines are also defined by accentuating the dark colors, especially the ones that are next to the most illuminated areas.

4

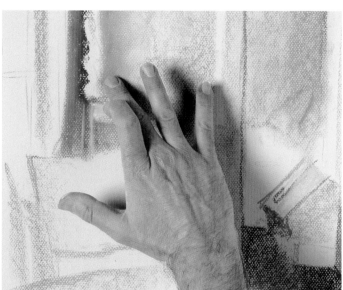

5

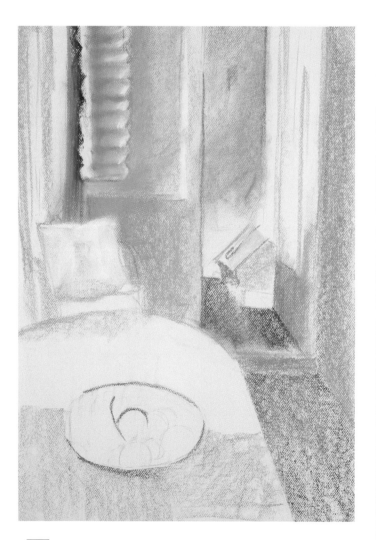

6

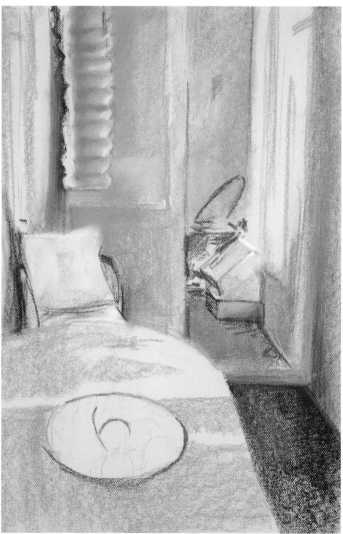

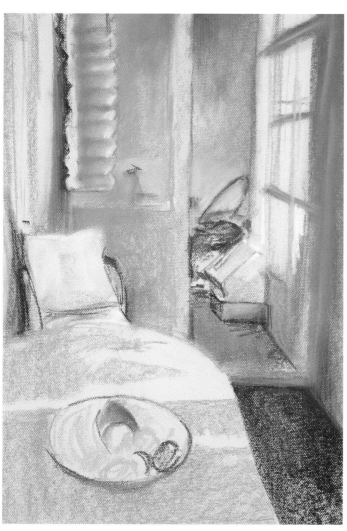

7

7. Now the artist focuses on the still life. The fruit is reduced to a few red and yellow lines. The direction of the lines suggests the shapes of the fruit. At this point the still life is only a combination of colors in the overall scheme.

8. As the work with the pastels progresses, the still life becomes much more defined: The yellow colors have evolved into ochre and orange tones with added yellow touches to highlight the volume. The reds have now turned into apples with their corresponding lights and shadows.

8

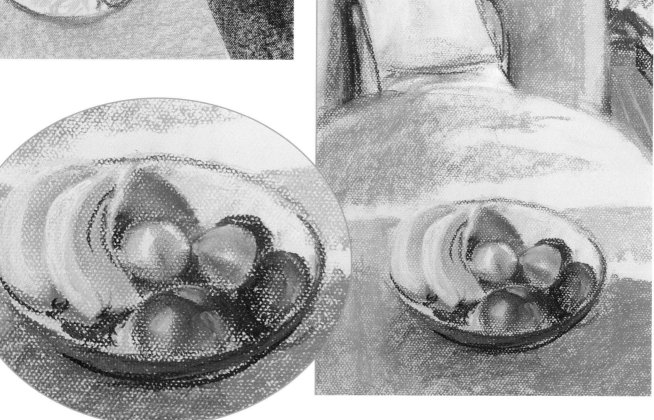

9. The objects in the back of the room were created with an array of multicolor lines that suggest the forms without defining them completely. They relegate this area to a plane of secondary importance within the composition.

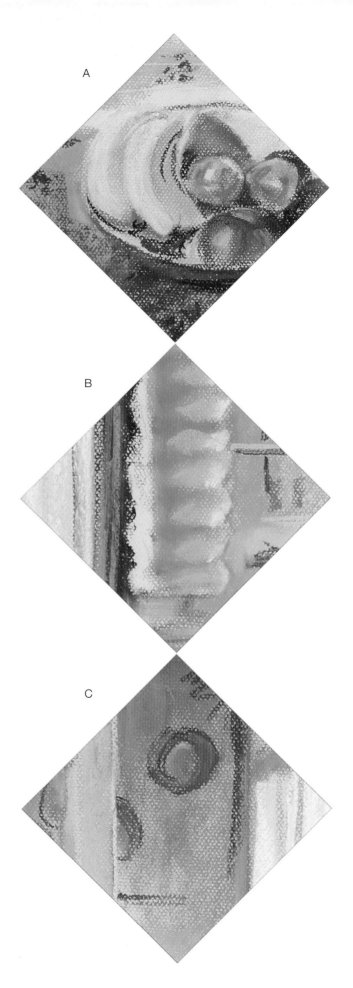

A

B

C

THE ARTIST COMMENTS

The spatial complexity of the final result responds to two essential factors: the contrast between the most illuminated areas and the shadows, and the contrast between warm and cool colors. This dual contrast has made it possible to keep the shadows light and bright, as called for by the theme itself. The still life (A) is a detail of great quality and artistic appeal in a composition consisting of soft colors. Several of the volumes are particularly interesting, such as the shape of the lamp (B), drawn with great detail and attention. Other significant details (C) that add precision to this intimate scene have also been addressed.

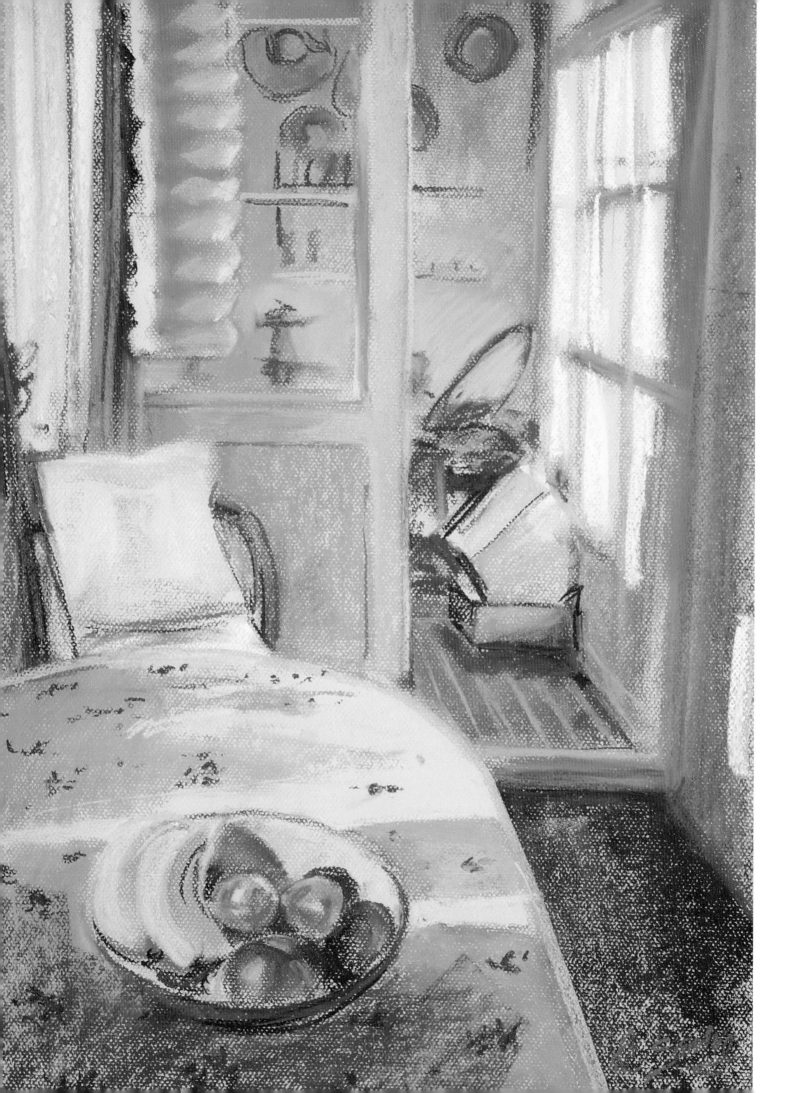

Flowers Using Warm and Cool Colors

The chromatic richness of this theme is a response to the bright colors of the flowers and the contrast of their warm tones (carmine, pinks, and yellows) and the cool color scheme of the blue vase in which they are displayed. The artist, Mercedes Gaspar, achieves great pictorial results with these contrasts. The approach is deliberate and delicate: The artist pays great attention to the form and the color of each flower against a background that is neutral but rich in shades.

1. The preliminary drawing is extremely simple; it consists of a few lines that capture the basic features of the still life. The lines have a pink undertone and lay out only the space of the composition, defining the placement of the elements in the motif.

1

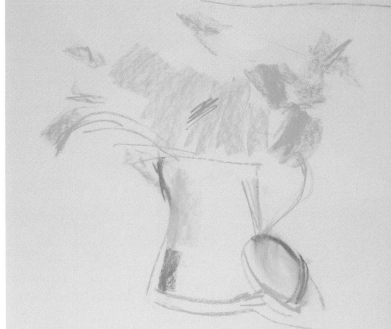

2

2. The first colors are applied loosely the same way the artist drew the preliminary lines. The areas of yellow color define the overall mass of the flowers and are applied with wide, quick strokes.

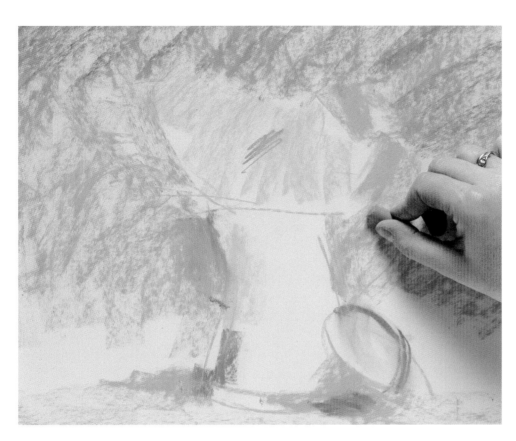

The artist uses the margins of the paper to test the exact color of the sticks before she begins the work. This is common practice among watercolor and pastel artists.

3

3. Next, the artist paints the background, superimposing areas of blue color with warm gray. Notice the energetic and deliberate approach to these applications.

4. A blending stick is used to extend and blend the lines, which creates a soft and continuous surface. The artist paints the vase with very bright blue, which is left unblended. The color of the background partially overlaps the yellow areas to prevent the contrast between the background and the flowers from appearing dull and artificial; this is how the artist creates a pleasing and chromatic setting.

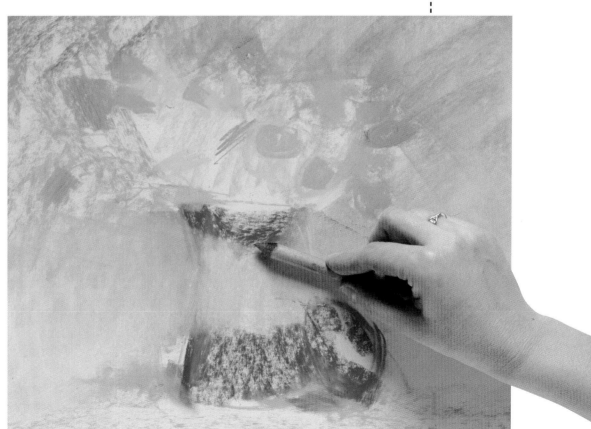

4

5

5. After blending, the color lines become blurred and the contrast between the bright colors becomes less pronounced. In its place, a unified and balanced tonal composition has been achieved, out of which specific forms begin to emerge from within the overall harmony.

6. The shapes of the flowers begin to emerge from within the colors as if surrounded by fog. Notice how effectively the artist has painted the flower buds with only a few strokes of color. Little by little, the real outlines of the flowers begin to take shape.

6

7. The leaves that stand out from the floral mass not only create color contrast but also help to define the shapes of the yellow flowers. But it is on the vase where progress is most clearly visible: The color and the shiny texture are almost completely finished, thanks to the careful blending work.

8. Little by little each of the flowers has been defined, making each stand apart through its shape and size. But not all the areas have become flowers: Some of them have been left unfinished to give the bouquet a more whimsical appearance.

7

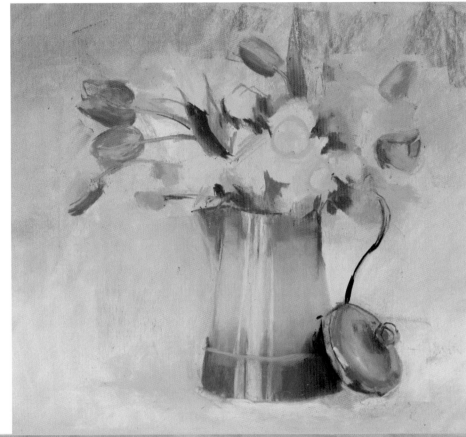

8

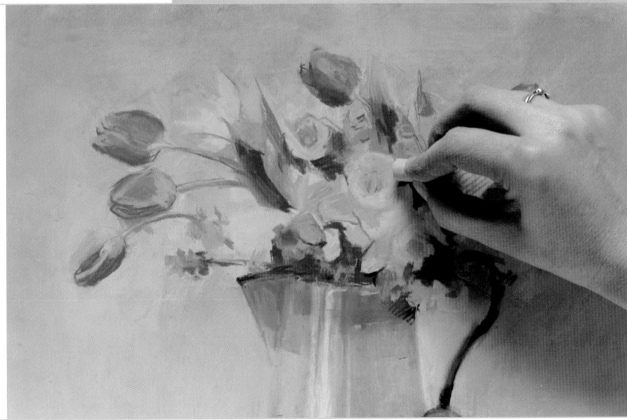

9

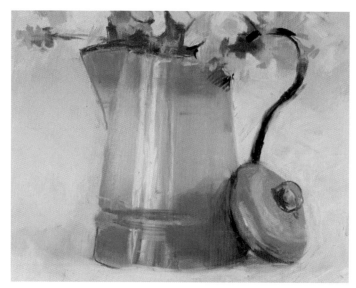

9. The realistic treatment of the vase is in fact very simple: The blue colors have been blended, and over them lighter tones have been added to achieve the effect of a smooth and shiny surface.

THE ARTIST COMMENTS

This work of art has an elegant realism. All the details have been addressed perfectly in such a way that the overall harmony and feeling prevail over the descriptive details. Such details as the flower buds (A), which have a proper and precise definition, stand out against the looser and more undefined treatment of other areas of the flower mass (B). The artist has not disregarded secondary details such as the lid of the vase (C), which has the same metallic, shiny texture and has been resolved with very few applications of color.

A

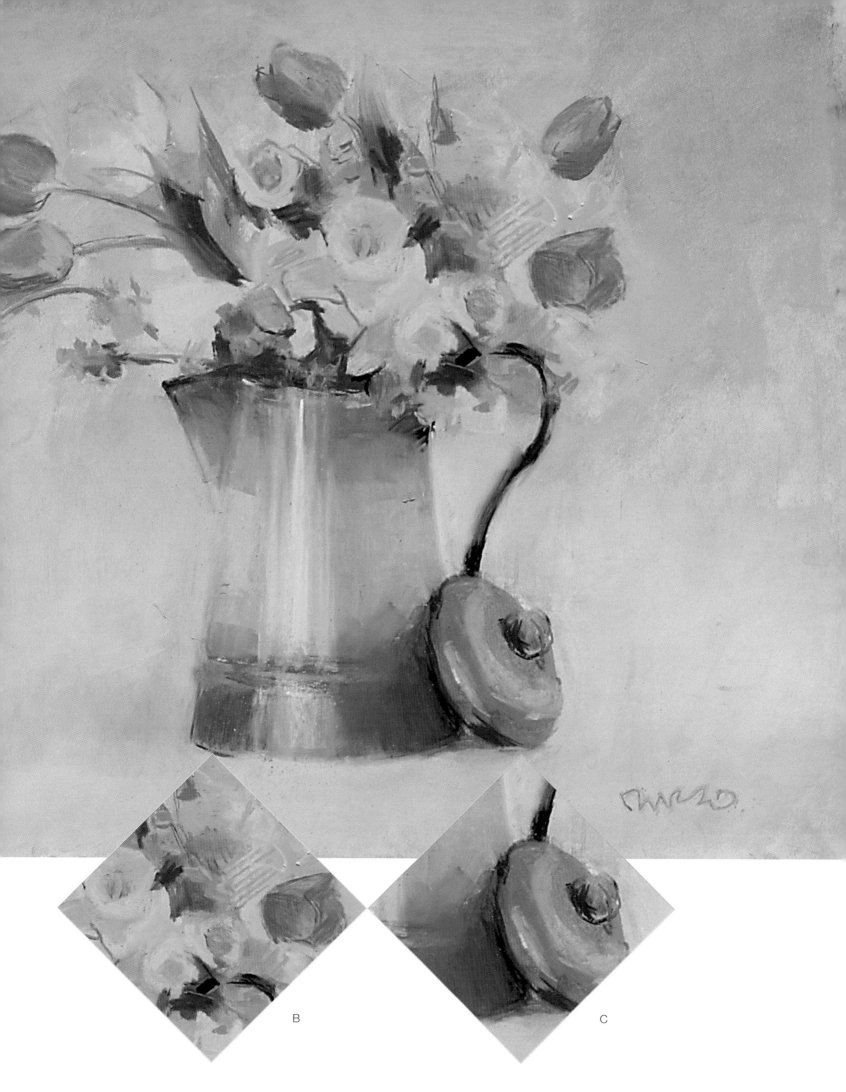

B

C

The purpose of this project is to show how to draw the human figure by combining color and chiaroscuro. This is a matter of showing contrasts, and the example was created by David Sanmiguel with few colors but very rich cool and warm tonal combinations. In this approach of contrasting tones the atmospheric quality will acquire special relevance.

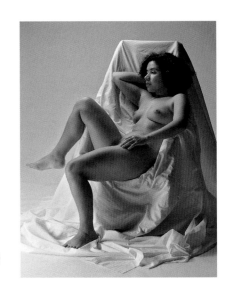

Female Nude with Chiaroscuro

1. The artist draws the figure with a hard ochre pastel stick, paying special attention to the correct proportion and gesture of the limbs. This drawing addresses all the linear and anatomical elements of the figure. It is completed with the layout of the folds on the fabric using a gray pastel stick.

1

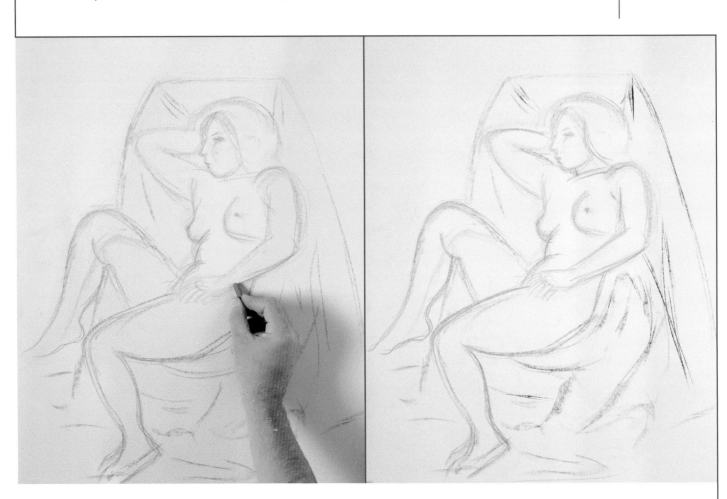

At this early stage the face has simple, but very effective, lines: The volumes are already present, and not much more will have to be done until the final stage of the work.

2

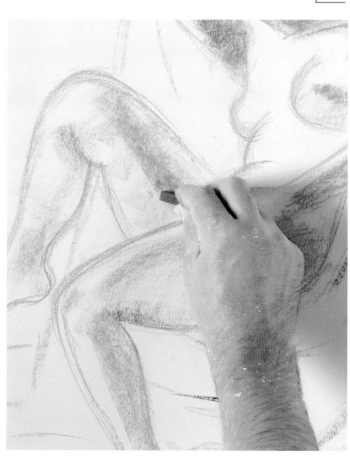

3

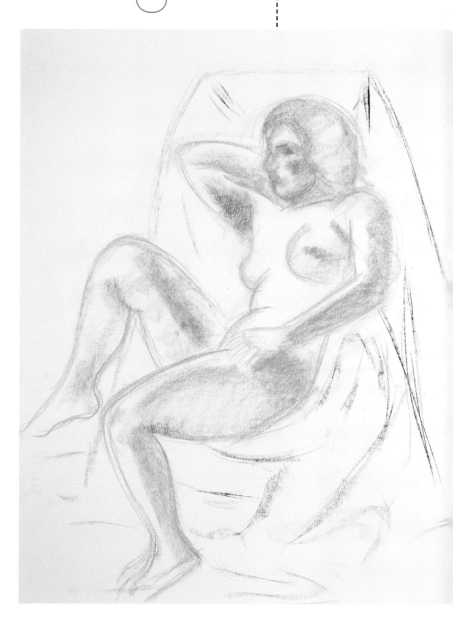

2. Using bright pink and orange colors, the artist begins to paint the skin. The middle area is painted first, the one that is between the light and the shadow: the medium value. The areas that should be darkened and the parts that hardly have any color are left unpainted.

3. The rose tones highlight the volumes of the anatomy. These unblended areas reveal the approach to the theme: firm and volumetric.

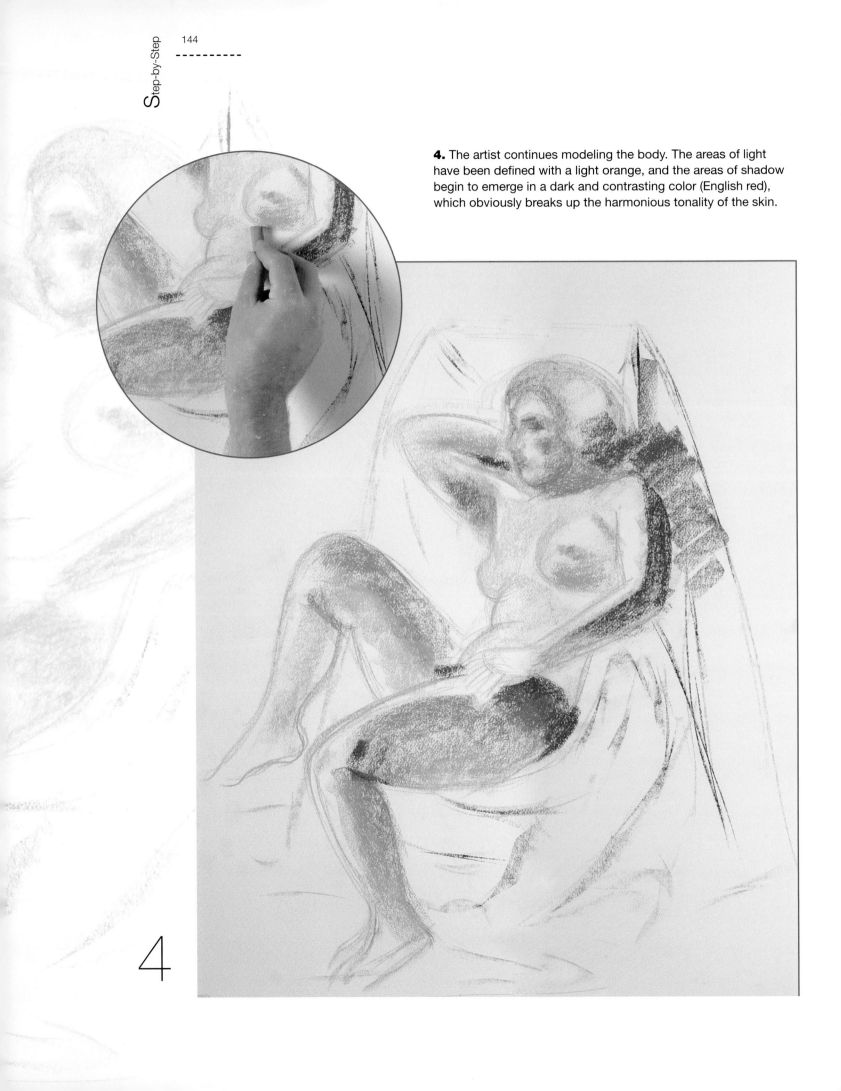

4. The artist continues modeling the body. The areas of light have been defined with a light orange, and the areas of shadow begin to emerge in a dark and contrasting color (English red), which obviously breaks up the harmonious tonality of the skin.

4

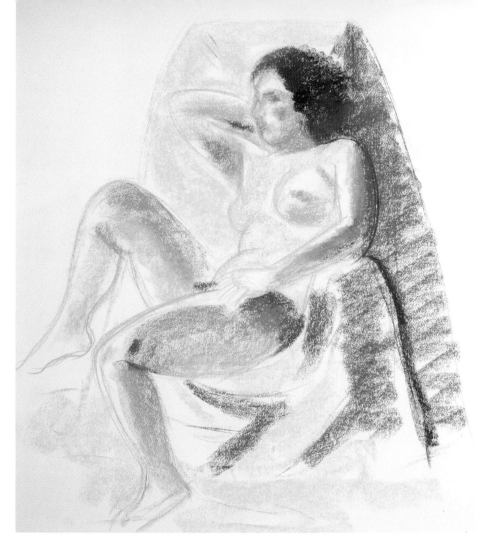

The areas of light on the folds have been created with an eraser, to recover the white of the paper. Those areas have then been touched up with white pastel.

5

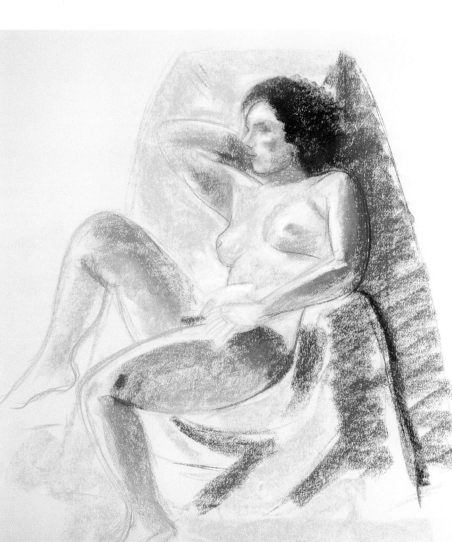

6

5. The strong contrast of the dark colors has been softened by blending the transition between light and shadow. Also, the area behind the figure has been darkened with large applications of brown, which will be addressed later when painting the details of the folds.

6. It is important to create a play of sharp and marked contrasts on the folds to try to make them coherent, and also to make sure that the distribution of light and shadows forms an interesting contrast against the rounded volumes of the figure.

7. To create an interesting contrast that gives the figure a warmer quality, the artist has painted all the drapery with cool gray colors that greatly contrast with each other. Among those grays are black lines that define the folds of the fabric.

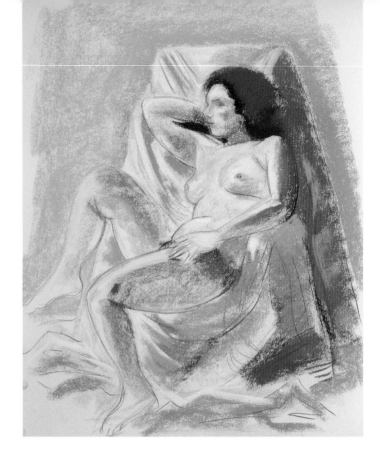

THE ARTIST COMMENTS

In the end, good balance has been created between the modeling of the body and the drapery, as well as a pleasing luminous and chromatic environment. The chiaroscuro is especially accurate on the figure's head (A), where the strong contrast between the modeling of the face and the almost black tones of the hair stand out. On the thigh (B) the chiaroscuro has been resolved by heavily blending the red tones. Some parts, such as the figure's right foot (C), have been left blurry so they can become part of the light that bathes the figure in that area.

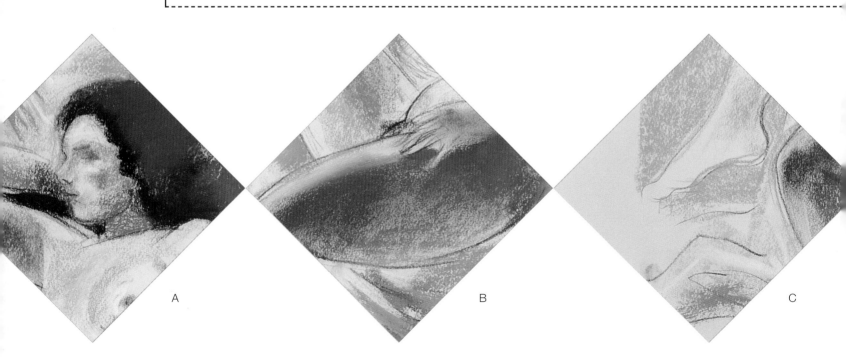

A

B

C

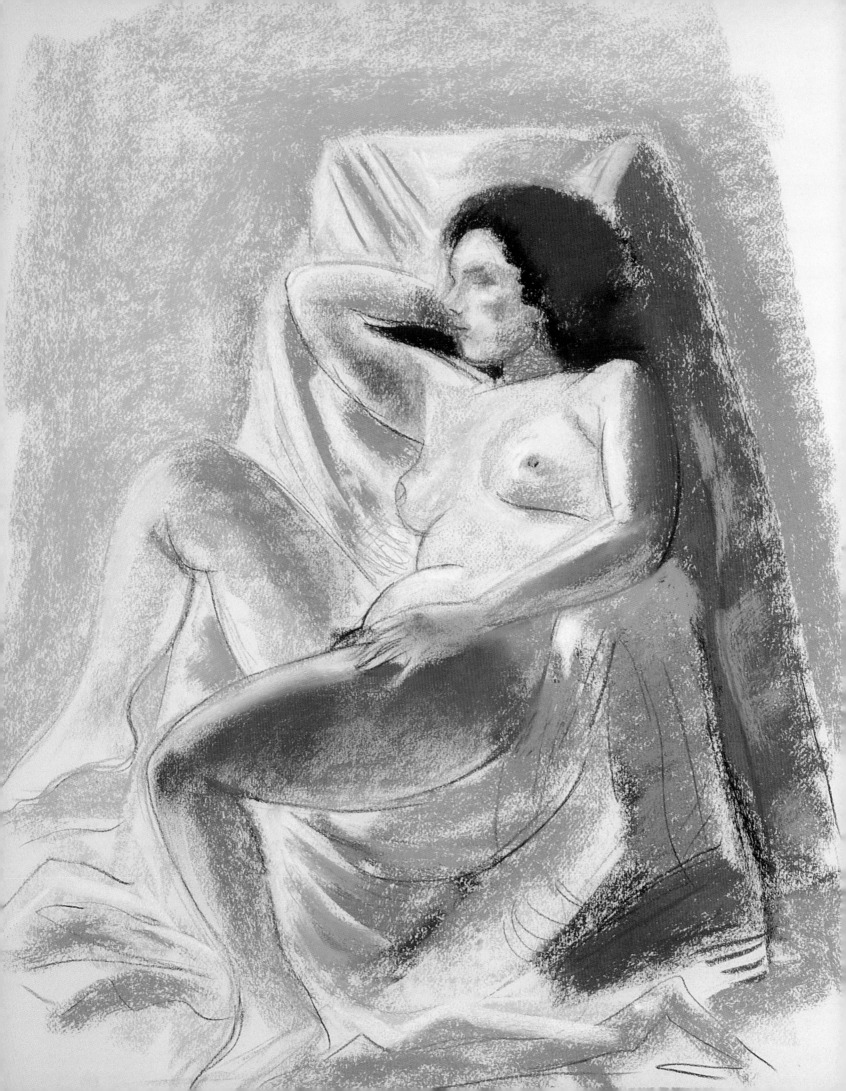

Line and Color in a Figure

This project clearly involves the use of outlines to which color will be added. After studying the pose, we will see how David Sanmiguel forms a single and contained block that is hardly altered by the arm resting on the sofa. It also describes a rotation that is clearly expressed by the line of the spine (another element of drawing), which forms a rounded line that is very pronounced. This pose could be sketched out with a single line from the base of the buttocks to the nose, including the spine, the nape, the cranium, and the forehead. This rounded and continuous aspect of the lines of the back also affords the possibility of interpreting the pose with arabesques.

1

1. The artist draws the figure with a heavy pink line.

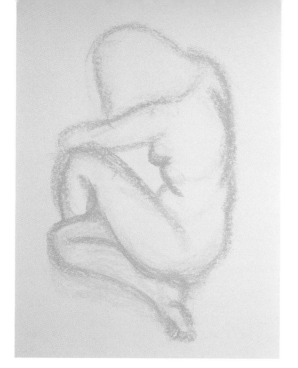

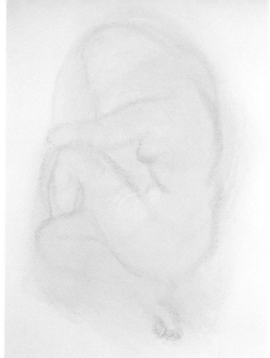

2. The line will be blended completely, so it is not necessary to define it too much to adjust it to the anatomy, because the form will be completely reconstructed during the process.

3. The artist blends this drawing overall, using a clean rag. The lines are only partially erased because the paper retains traces of the original lines.

4. Over those traces the artist redraws the figure, defining its contours with more precision. Those outlines are defined with a red oxide color that is blended with the fingers.

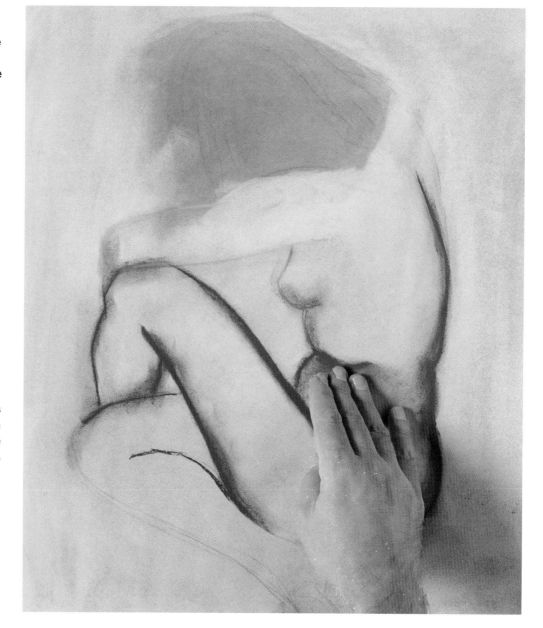

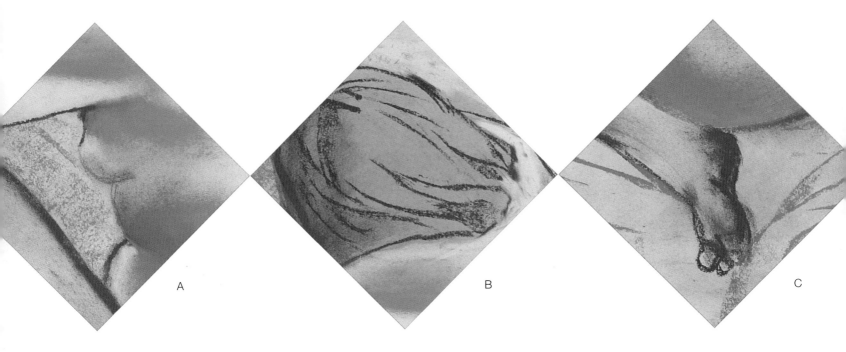

A

B

C

5. The modeling of the figure is reduced to a few areas of color that are heavily blended only in the outer areas of the anatomy to highlight its volume. The colored surface suggests an airy chromatic composition that makes up for the simplicity of the drawing. The drapery that surrounds the figure is represented very lightly with a number of purple lines.

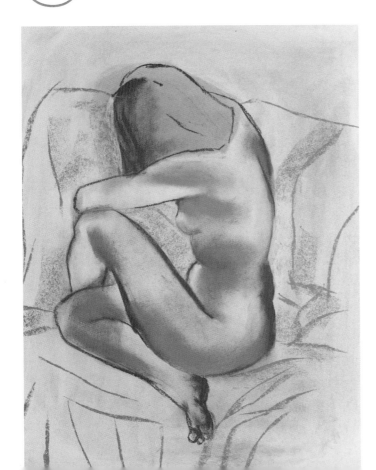

THE ARTIST COMMENTS

This work resembles a drawing more than a painting, but its color vibrancy is evident. This vibrancy is the result of the airiness of the composition and the blended lines of the anatomy, all of them done with the same rosy color (A). In the areas that have not been blended, the artist made use of simple lines to define the form and the volume of the figure (B). In the simple details such as the foot (C), we can appreciate the effective use of the monochromatic drawing in the definition of the form and in the suggestion of its color.

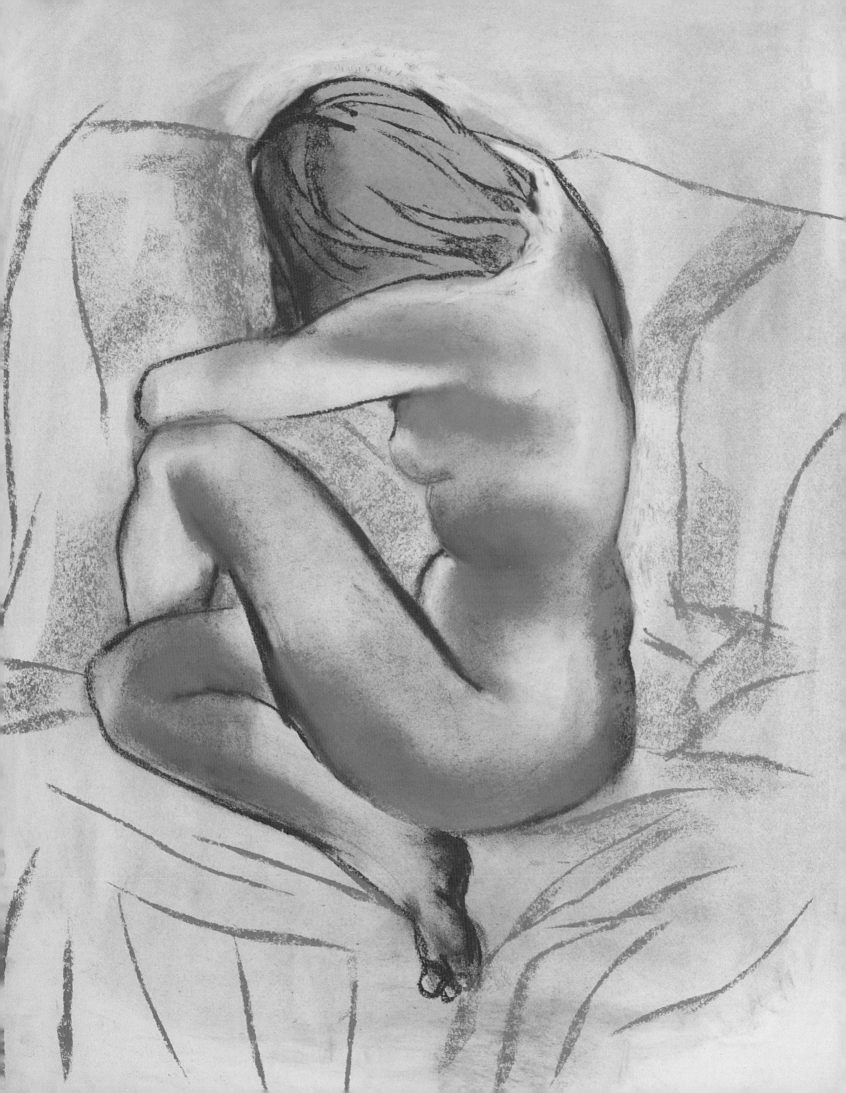

Interior with a Figure:
Light and Atmosphere

The color, the light, and the charming figure make this theme a truly appealing subject matter for any painter, regardless of the method used. For Mercedes Gaspar, this is an opportunity to explore all the possibilities of painting with pastels to define the atmosphere and the light. The subject called for a patient and careful approach and was executed brilliantly.

1

1. The initial drawing is basically one of composition. The lines lay out the space to organize the main masses: vertical and horizontal for the furniture in the background, and curved forms for the figure and the stuffed bear.

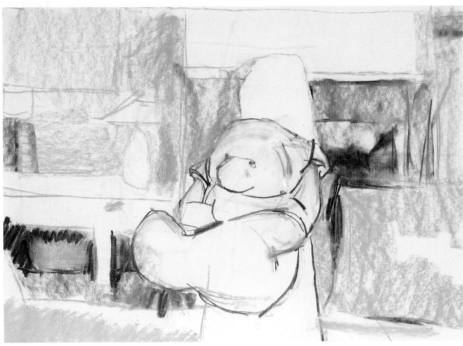

The blue lines of the background very lightly show through the original areas of applied color. This will allow the subsequent modeling colors to remain clean and unaltered by the initial drawing.

2. The darker areas of the composition have been colored with charcoal, and the background has been painted with ochre and yellow colors, leaving the figure unpainted. These areas of color have been applied with the pastel sticks flat on the paper.

3. The first colors on the figure are the grays, which are applied on the toy, and a few touches of orange on the hands and face. These are the base colors, the block-in colors, the colors that create a background over which the artist will define and include details later.

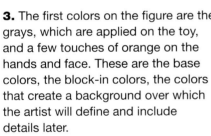

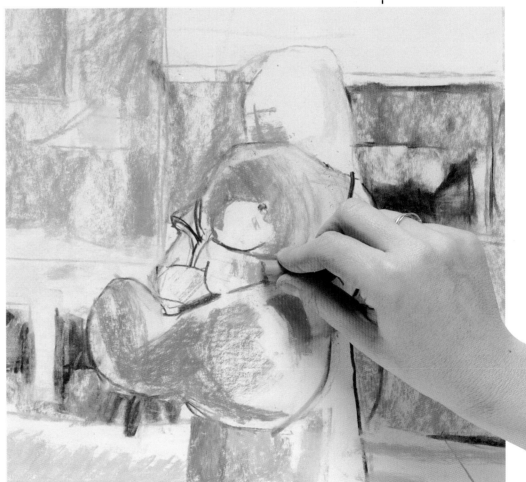

4

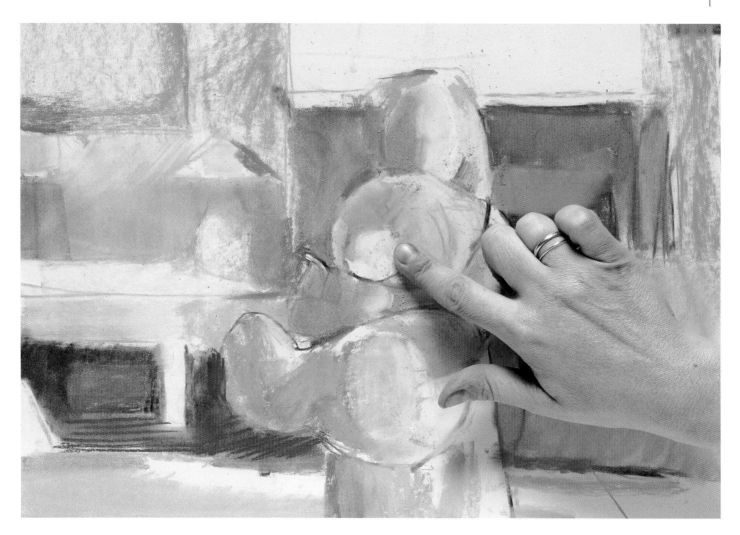

5

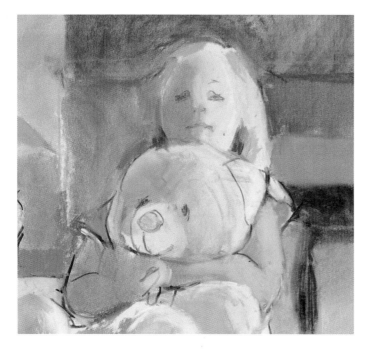

4. The colors are blended as soon as they are applied. The blended areas provide the initial general forms of the arms and the face, leaving the areas of light unpainted. This modeling should be very general, because the lines of the drawing will define the details of the face and hands.

5. A few extremely delicate and precise black lines define the facial features and the form of the hands, as well as the features of the stuffed bear. These graphic notes extend equally to the furniture in the background, whose color has been blended as well.

6

6. The darkest colors are applied only when the overall harmony of the composition has been properly established—in other words, when we are sure that the colors will not change substantially and will not have to be corrected. Otherwise, fixing one of these dark colors would muddy up the entire area.

7. The approach of the artist consists of blending and constructing the contours successively, defining the colors more and more each time. Here, multicolor lines make their appearance to define the outline lost by the continuous blending.

The pictorial work done on the figure's face is very interesting. In a small area, the artist has created a delicate and soft modeling that clearly defines with clarity the main features of the face.

7

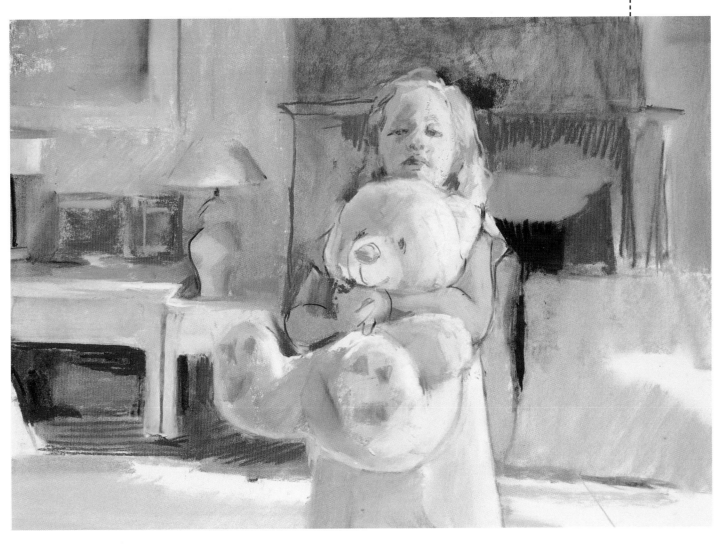

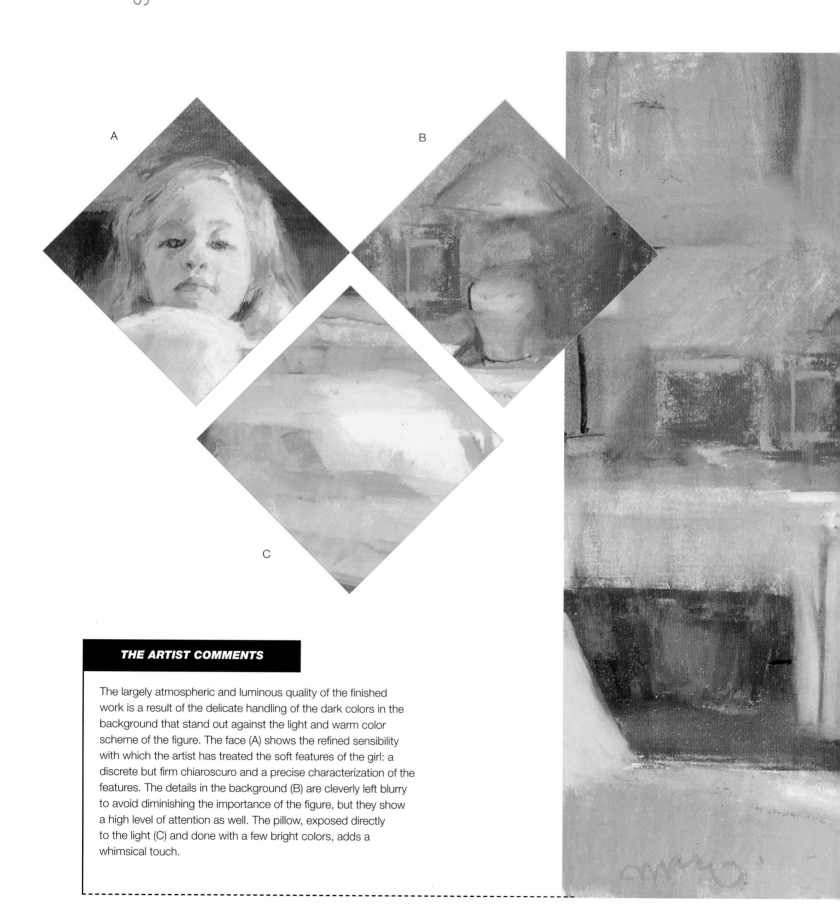

A

B

C

THE ARTIST COMMENTS

The largely atmospheric and luminous quality of the finished
work is a result of the delicate handling of the dark colors in the
background that stand out against the light and warm color
scheme of the figure. The face (A) shows the refined sensibility
with which the artist has treated the soft features of the girl: a
discrete but firm chiaroscuro and a precise characterization of the
features. The details in the background (B) are cleverly left blurry
to avoid diminishing the importance of the figure, but they show
a high level of attention as well. The pillow, exposed directly
to the light (C) and done with a few bright colors, adds a
whimsical touch.

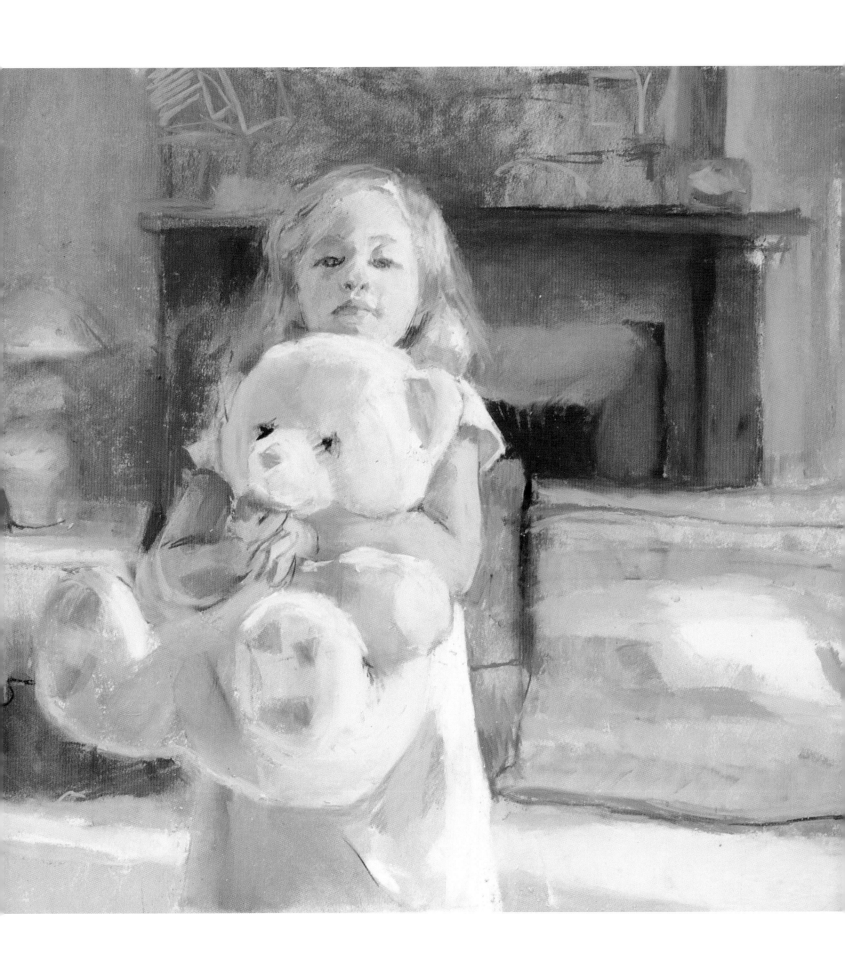

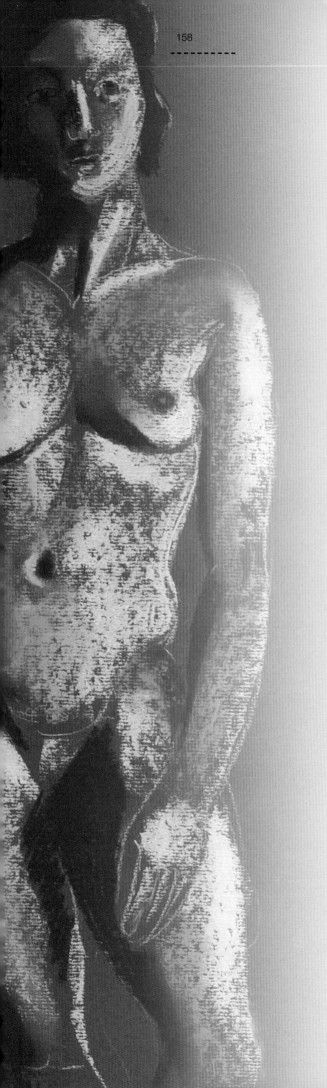

A

Agglutinate. This substance is mixed with a powdered pigment to give it consistency. Tragacanth gum is the traditional agglutinate for pastel paints, although today manufacturers often use cellulose glue. There is a much smaller amount of agglutinate in pastels than in any other media.

Atmosphere. This is created by gradating tones to suggest the air that exists between the foreground and the background of a painting. Sometimes this is called *chromatic atmosphere* to indicate the particular color harmony of a work of art.

B

Backlighting. A lighting effect produced by placing the light source behind the object to be drawn or painted.

Blending. Light and continuous gradations of a stroke made with charcoal, chalk, or pastel. This can be done with the fingers, a blending stick, or a rag.

Blending Stick. A cylinder of absorbent paper with a point at one end that is used to spread or lighten charcoal, chalk, and pastel strokes.

Blocking In. A drawing technique that consists of drawing a simple form that encloses and suggests a more complex form. Blocking in uses geometric shapes that help indicate the proportions of the real forms.

Blurring. The technique of rubbing the outlines of objects to blend them into the background.

C

Cast Shadow. A shadow that is cast by an object onto the surrounding surfaces.

Charcoal. A carbonized stick of willow or linden that is used for drawing.

Charcoal Pencil. This pencil, made with compressed charcoal, is used for small-format drawings.

Chiaroscuro. This artistic technique is based on juxtaposing light and shadow, using hatching or blocks of dark tones.

Complementary Colors. Pairs of colors consisting of a primary color and a secondary color made by mixing the other two primary colors. Complementary colors create the strongest of all color contrasts.

Conté Pencil. The lead of this pencil is made of black pigment agglutinated with clay. Its line is very dark and somewhat greasier than graphite.

Cool Colors. This range of colors consists of the blues, greens, mauves, and violets. These colors are associated with shadows, and they seem to recede from the foreground in a painting.

Colorism. A painting style that makes use of color and color contrasts rather than chiaroscuro and monochromatic approaches.

Chalk. A generic name for leads and sticks of hard pastels in black, white, sanguine, and sepia. It is named for the white calcareous rock.

GI

D

Drapery. A representation of the properly modeled and shaded folds of cloth.

F

Fixative. A liquid aerosol that is sprayed on pastel paintings to keep the pigment from coming off the support.

Flesh Tones. The painted treatment of human figures and portraits, especially nudes.

Format. The proportion of a given support for painting: landscape, portrait, or square.

Foreshortening. The shortening of the dimensions of an object or a figure caused by perspective.

Framing. Selecting a meaningful fragment or view of a subject based on the format of the paper being used.

G

Gradation. An area of the drawing that shows a progressive decrease in the intensity of the basic tone. Gradations are created by blending the pastel lines or by gradually decreasing the pressure when drawing with pencils or hard pastels.

Graphite Pencil. This is the conventional pencil used for writing and drawing. Its lead is graphite agglutinated with clay.

L

Laid Paper. This paper is very popular among pastel artists. It has a characteristic texture or relief of parallel lines going in a single direction in the pattern of a screen.

M

Modeling. A shading technique that attempts to give the drawing a three-dimensional appearance by using blended tones.

Monochromism. Painting style that uses contrasts of light and dark rather than color contrasts.

N

Neutral Colors. A range of colors characterized by their muddy and undefined tones, which are usually grayish.

P

Pastel Pencil. A pencil whose line resembles those made with hard pastels.

Pigment. Mineral or synthetic powder that is used to make paint and pastels when mixed with an agglutinate.

Primary Colors. These are colors that cannot be created by mixing other colors. They are yellow, red, and blue.

R

Rubbing. Fusing two colors with a blending stick or the fingers. This eliminates harsh contrasts; the light tones gradually darken, and forms begin to look soft and rounded.

S

Sanguine. A brick red pigment that is used for making pencil leads and pastel sticks.

Sepia. A brown pigment used for making pencil leads and pastel sticks.

Shading. A drawing and painting technique that creates different amounts of light and shadow by lightening or intensifying the light and dark values.

Shadow. The lack of light on the surface of an object, always on the side opposite the light source.

Sketch. A study or quick, simple drawing for a painting or work of art.

Spanish Whiting. Calcium carbonate in powder form that is used to mix with pigments to stretch them, giving them body without affecting their color saturation. It is used for many art media, especially for manufacturing pastels. Champagne chalk is another variety of calcium carbonate popularly used in the manufacture of pastels.

Support. A surface that can be used for drawing or painting. Paper is the most common support for painting with pastels.

U

Underpainting. The technique of spreading generic color over the entire support as a preliminary approach to the subject.

V

Value. The intensity of a tone relative to other shades. Shading is based on the contrasts between values.

W

Warm Colors. This range of colors includes the reds, oranges, ochres, and earth tones. They are associated with light and give the impression of advancing toward the foreground in a painting.

Painting

Class

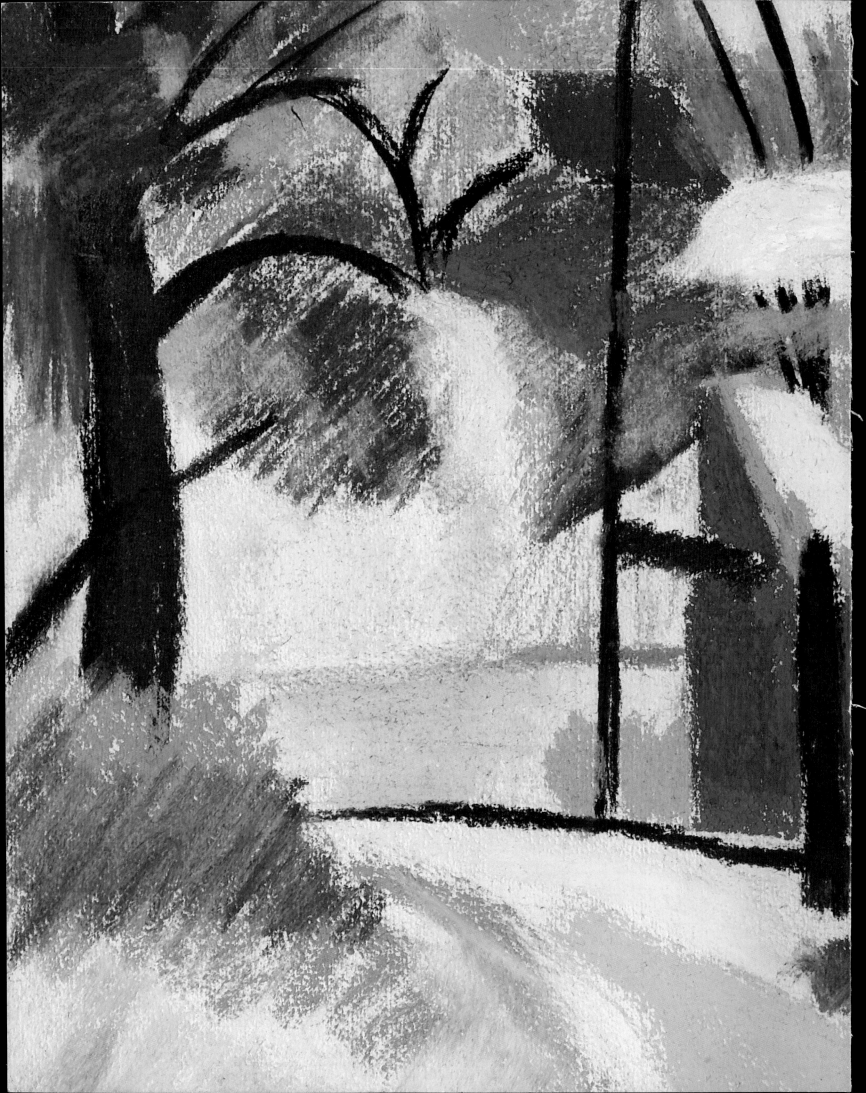